FRAGMENTS

Ellen H. Johnson, Oberlin College graduation picture, 1933

FRAGMENTS
Recalled at Eighty

The Art Memoirs of
Ellen H. Johnson

edited with an introduction by
Athena Tacha

gallerie

Canadian Cataloguing in Publication Data

Johnson, Ellen H.
 Fragments recalled at eighty: the art memoirs of Ellen H. Johnson

(Gallerie, ISSN 0838-1658; 12, 13)
Includes bibliographical references.
ISBN 1-895640-04-0

 1. Johnson, Ellen H. 2. Art historians—United States—Biography. I. Tacha, Athena, 1936— II. Title. III. Series: Gallerie (North Vancouver, B.C.); 12, 13.

N7483.J64A3 709'.2 C93-090383-8

Gallerie: Women Artists' Monographs is published four times a year, in March, June, September and December. Date of this issue: June 1993. Publications Mail Registration Number 7856. Series editor: Caffyn Kelley. Printed in Canada.

Front cover: Alice Neel, *Portrait of Ellen Johnson*, 1976, oil on canvas, 44″ × 32″, Allen Memorial Art Museum, Oberlin College, Oberlin, Ohio; R.T. Miller, Jr. Fund and gift of the artist in honor of Ellen Johnson's retirement; photo: John Seyfried

A memorial fund created by Ellen Johnson's friends and students supported publication of this book.

CONTENTS

ELLEN H. JOHNSON, 1910-1992

In 1975, Linda Nochlin wrote in *Art in America*, "in no other college has the positive interaction between new work, artists and audience been more deeply and consistently felt than at Oberlin in Ohio. And, as is so often the case, there is a moving spirit behind Oberlin's role as an innovating, sympathetic setting for contemporary art: Ellen Johnson."[1] The occasion of Nochlin's piece was the auction held that spring at Sotheby Parke Bernet's in New York, a benefit to raise funds for Robert Venturi's new addition to the Allen Art Building at Oberlin College. Fifty-four works had been donated by artists, collectors and dealers because the museum addition was to be named "The Ellen Johnson Gallery of Modern Art." Prior to the auction, an exhibition of the works was held at the Castelli and Sonnabend Galleries, Soho's premier locations for contemporary art. Sotheby Parke Bernet waived their usual commission.

The list of donors reads like a Who's Who of the Art World and includes, among others, Frank Stella, Dorothea Rockburne, Robert Rauschenberg, Agnes Denes, Claes Oldenburg, Christo, Nancy Graves, Jasper Johns, Roy Lichtenstein, Miriam Schapiro, Jasper Johns and Andy Warhol. The auction was a success, but what is pertinent here is how a teacher of art history at a Midwestern college could have elicited such a generous response in the Big Apple.

The story could begin around 1915 when, Johnson recalled, "I was about five years old ... I was standing on the porch in the late afternoon ... looking out over the river and the island. I'd just had a bath and had on a fresh dress and my hair was all brushed and combed. I felt so clean and so much a part of the beautiful sky and trees, and I was looking over the hills across the river. I think that's when I first became interested in art."[2] Growing up in glorious nature

along the Allegheny River on the outskirts of Warren, Pennsylvania, where Ellen Johnson was born into a tightly-knit Swedish-American family on November 25, 1910, she had little contact with art as a child. But that was to be remedied at Oberlin, where she earned both the Bachelor's and Master's degrees in art history, in 1933 and 1935. For the M.A. she wrote a thesis on *Modern Art and Its Traditional Aspect*, in which the twenty-five year old already was defending contemporary art: "Is it not the better part of valor," she asked, "to face the puzzling thing, study it, and honestly try to understand it for what it honestly is, rather than to wait for History to put it in its proper place?"

Johnson spent the following three years working in the education department of the Toledo Museum of Art, lecturing and cataloguing its library, prior to returning to Oberlin as art librarian in 1939. A born evangelist of art, she soon had a foot in the classroom door by offering not-for-credit (and not-for-pay) classes in contemporary art and museum studies. Meanwhile, she raised funds and started Oberlin's Art Rental Collection (1940), the first of its kind in the country. That was a project she oversaw with particular devotion because, as she put it, maybe living with art would develop the students' aesthetic sensitivities and encourage ordered thinking and discrimination in other areas of their lives. Nothing gave her greater joy over the years than to see students so eager to rent works of art that, in the dead of winter, they'd camp out all night on the museum lawn so as to be first in line for the Rental.

During the 1940s, Johnson also organized Oberlin's first film series and the museum's first Purchase Shows, which brought to campus inexpensive original works of art that students and the public could buy. In 1948 she joined the faculty with a regular appointment, subsequently teaching nineteenth- and twentieth-century art, a museum course, American art from Colonial times forward, contemporary art, and Scandinavian art, the only such course in the country.

Johnson's teaching was legendary. There was nothing flashy in delivery—only an occasional red velvet cape might be called that. But one knew, when listening to her discuss Monet or Cézanne, Pollock or Oldenburg, that here was a voice of reason and love, of disciplined historical analysis and critical passion. "It's so magnificently useless," she once said of art, "and therefore it's not material, it's spiritual."[3]

Students sensed the spiritual in her courses and signed up in

unprecedented numbers. Because she believed so deeply that *all* students should have the opportunity to learn about art, she never was willing to limit enrollments. At the end of her career she let some four-hundred-and-fifty students into Modern Art, which had to be taught in the College's theater auditorium. Reluctantly she devised exams with some questions that assistants could score—but she insisted on reading the essay parts of all four-hundred-and-fifty bluebooks and determining the grades. In 1977 *Newsweek* featured Ellen Johnson among only seven college professors in America who were "closing out long and distinguished careers in the classroom and personified the best of their profession."[4] The following year she was the recipient of the College Art Association of America's first "Distinguished Teaching of Art History Award."

Ellen Johnson did postgraduate study at Columbia and the Universities of Paris, Uppsala and Stockholm, but few realized—and certainly no one could tell—that she never had earned the usual prerequisite to tenure, the Ph.D. (Her Alma Mater rectified that in 1982 by awarding her an Honorary Doctorate of Fine Arts.) That she nonetheless was tenured at Oberlin, and became one of the rare women full professors of her time, indicates the exceptional quality of her teaching and scholarship, the dynamism of her personality, and her unfaltering devotion to the College. "Don't ever think Oberlin is in the middle of nowhere" she said with the deepest conviction; "it's an extraordinarily special place."[5]

These and other biographical facts of course cannot explain why, as a child in Warren, Ellen Johnson already felt a connection between natural form and human-made beauty, nor why she believed so deeply that art produces a sense of well-being. What is clear is that her teaching, like her writing and travel, and like her loving restoration of the Frank Lloyd Wright house that she purchased in 1968 and arranged to become a College guest house for visiting artists and art historians, were all manifestations of a drive to explore, explain, and enjoy the beauty of Order.

The discipline, order and sensitivity that marked her lectures also characterize her writings. Numbering nearly a hundred, on Scandinavian, American and especially modern topics, they include books on *Cézanne* (Penguin Art Books, 1967) and *Claes Oldenburg* (Penguin, 1971), a collection of her essays entitled *Modern Art and the Object* (Thames & Hudson, London and Harper & Row, New York,

1976, revised and expanded edition Harper/Collins, New York, in press), and *American Artists on Art from 1940 to 1980* (Harper/Collins, 1982), a source reader that reflects her pedagogical view that students must read what artists, not just critics and historians, say about art.

Reviewing *Modern Art and the Object*, Suzi Gablik wrote: "Ellen Johnson never adopts that dogmatic form of conviction which so often restricts the critic's vision... she achieves what Harold Rosenberg has described as the true function of the modern critic: to be the intellectual collaborator of the artist."[6]

When Richard Morphet, Keeper of Modern Art at the Tate Gallery in London, reviewed *Modern Art and the Object*, he sensed in the book what Oberlin students saw in the classroom. "She is like a surgeon," he wrote, "penetrating beneath the external appearance to reveal, with precision and objectivity, each of the multiplicity of separate strands of the artist's engagement ... Illuminating art, there runs through these writings a passionate personal response to nature in all its forms."[7]

Behind Johnson's response to nature lay her study trips in search of the precise locations painted by Monet, Van Gogh, and Cézanne. She described one such journey with the poignancy and poetry of her subject: "Approaching L'Estaque from the north was like driving right through the back of Cézanne's painting, and when I saw it from out at sea, that part of the mountain he had painted was right there in every single contour. Even now, after forty years, I still tingle to remember— more than that—to experience once again the shock and joy at that first recognition."[8]

Johnson's international reputation as a scholar and critic, especially as a leading voice for the so-called "Pop" artists, was increased further through the exhibitions she organized. With exceptional foresight, she selected for Oberlin's *Three Young Americans* exhibitions such major figures as Oldenburg, Rauschenberg, and Joan Mitchell in 1963 before they were well-established in the art world. In 1968 she was invited by the Smithsonian Institution and the United States Information Agency to be the Commissioner of the First India Triennale of Contemporary World Art. And in 1982 she organized for the Oberlin museum *Eva Hesse: A Retrospective of the Drawings*, an exhibition that circulated nationally.

The Oberlin museum named her Honorary Curator of Modern Art in 1978 in recognition of the extraordinary contributions she had made to the formation of its post-War collection, to its exhibitions program, to its Purchase Committee, and to its fund raising. (She was responsible for Ruth Roush establishing the Fund for Contemporary Art in 1964 and giving $1.5 million toward the Venturi addition.) Moreover, not only have works by Paul Klee, Robert Motherwell, Mark Rothko, Adolf Gottlieb, and Alice Neel, among many others, been donated to the museum in her honor, but Johnson bequeathed to the museum her personal collection of nearly three hundred objects and to the Department of Art an endowment for visiting artists.[9]

Other honors came her way, as a Fulbright scholar, and from the American-Scandinavian Foundation, the American Council of Learned Societies, twice from the National Endowment for the Humanities, from the Guggenheim Foundation, from the Women's Caucus for Art, and from the Universities of California (Santa Barbara) and Sydney, where she lectured as a Distinguished Visiting Professor after retirement. She especially treasured her Australian stay because of the beautiful landscapes and the Great Barrier Reef. Until the age of seventy-nine and despite two artificial hips, she was an inveterate traveler and avid snorkeler, often in the Caribbean, and especially in Greece, which she loved deeply and visited every year, never tiring of the Aegean blue, the scent of pines and thyme, and watching sunsets from a bungalow at Lagonissi, where she wrote many of her articles.

When she told an interviewer in Australia that "we're all too much alike already and we want to be new and different, but ... new and different in the same way. We're afraid to stand alone ... the courage to stand alone is a fundamental ingredient in the original artist's makeup," she might have been characterizing herself.[10] For, new and different she was, and never afraid to stand alone. While her perfectly honed prose reflects her rational and logical mind, she had a spooky ability—as I can personally attest—to read palms. Tenacious, even stubborn, in her beliefs, she was also deeply compassionate, one of the best listeners imaginable, which in part is why she established so many close and lasting friendships. Her boundless energy was awesome. She would tire companions half her age who tried to keep up with her as she climbed endless steps to artists' lofts in New York. Despite her accomplishments and reputation, she was modest and self-doubting. At the core she was a critic in the best sense of the word—not only of

art, but of family, friends, herself, and, with particular joy and discrimination, wine.[11]

Ellen Johnson died on March 23, 1992, aged eighty-one, having battled cancer for the second time. During her final years she wrote the following memoirs, which infinitely better than these few words illuminate the career of an exemplary—and to those who knew her, unforgettable—teacher and scholar.

Richard E. Spear
Oberlin, 1993

NOTES

[1] *Art in America*, March-April, 1975, 27.

[2] *Art News*, April, 1975, 34. See p. 61 below.

[3] *Arts Melbourne and the Art Almanac*, December, 1977, 6.

[4] June 6, 1977, 90-91.

[5] *Oberlin Review*, November 23, 1982.

[6] *Art in America*, May-June, 1977, 35.

[7] *Studio International*, March-April, 1977, 158-59.

[8] See p. 48-50 below.

[9] A selection from her collection was catalogued and exhibited at Oberlin shortly before her death: *The Living Object: The Collection of Ellen H. Johnson*, catalogue and essay by Elizabeth Brown, Allen Memorial Art Museum, 1992. See pp. 141-47 for a list of works presented to the museum in honor of Ellen Johnson.

[10] *Arts Melbourne*, ibid., 8.

[11] In the final decade of her life she collected and enjoyed wine with as much passion as art. In a paragraph that she no doubt had intended to develop for the memoirs, she wrote: "About winetasting I have an annoyingly purist attitude: just the simplest, quietest cheese and crusty, very crusty French bread—occasionally a mild pâté, but nothing with a characterful taste—nothing the least bit assertive. No spices, no herbs. Of course wine belongs with food—some wines for this, others with that, but that's something entirely different since wines must be savoured and it's hard to really think about a wine if you have to separate that or those tastes (a wine has multiple tastes that must come together)."

ABSENCE IS PRESENCE
Introduction by Athena Tacha

Ellen Johnson started writing these memoirs while vacationing in Greece in the summer of 1989, probably because one of her god-children, Margaret Young, had asked her to recount the trips she had taken with her life-long friend and Margaret's mother, Chloe Hamilton Young (who had been curator of the Oberlin College art museum). Indeed, Ellen wrote initially a fourteen-page "letter to Margaret" recalling, with her characteristic humor, her travels with Chloe through Europe at the end of World War II. At the close of that summer of 1989, Ellen fell down a cliff in Greece. She cracked her spine and barely survived a nine-hour operation and long hospitalization. It seems that during those interminable months in bed, in Greece and then back in Ohio, while ruminating about her life and undoubtedly about death, too, she jotted down notes, mainly on her art career—and she even started scribbling this text.

The following summer, after finally getting back on her feet from the accident (and managing to go snorkeling in the Caribbean!), it was decided that she needed to have another very difficult operation, replacement of her left, already artificial, hip, which inevitably prevented her from returning to her beloved Greece. In between these operations and during the months following the second recovery, she completed and typed the first five sections of this text. Having gotten feedback and editorial suggestions from Richard Spear and me, in April of 1991 she sent it to Nikos Stangos, her former editor at Thames and Hudson who had become a dear friend and whose response encouraged her to continue writing. Shortly later, she had to undergo surgery yet again, for a colon tumor, which turned out to be malignant and had already moved into the liver. The prognosis was no more than a year of life at best. Undaunted, and working as hard as ever through pain and drugs, Ellen wrote and typed the last part of her memoirs by the end of 1991, when she entrusted me with publication of the manuscript. She had agonized over her prose relentlessly as usual, fussing about each single comma; and she produced the most mature, free and personal piece of her many writings.

As I was checking the handwritten original text after her death, I found with it a list of some twenty-five variations on titles that she had considered and rejected for the memoirs (she always thought very hard about titles). Most of these alternatives contain the word "fragments" and the concept of time or recollecting, in one form or another. Additionally, there were a lot of notes on more memories that she would have liked to have written about. The subjects that she never developed ranged from childhood and family memories (especially related to her mother, whom she adored), to travelling in Europe with Chloe and her other curator friend, Hedy Bäcklin Landman, to reading palms at various art-world parties (including openings of Documenta). There is no question, therefore, that these are not, nor were they ever meant to be, "complete" memoirs. Even when sequential for awhile, the narration is full of discontinuities, backtrackings and time insertions, flowing like a river but constantly surprising you by changing direction. Yet, because Ellen knew that time was running out, she dealt with the subjects most essential to her, primarily those involving art and related travels.

This text is indeed a testimony to how much art can be an all-consuming part of a person's life and become totally interwoven with it. It is also a text about memory and the act of recalling. Ellen Johnson was a person who cherished every bit of her life and kept unbelievably meticulous records of everything she did, whether travel, stocks purchased, wines drunk or gasoline expenses, not wanting to relinquish anything that she lived. She also was one of those individuals whose rich mind, love of life and endless energy somehow lend glamour even to common events and places—one of the rare people who create legends. Those who knew her well (and shared with her some of the incidents narrated here) can testify to how, even when extremely accurate, her memory seems to imbue reality with a glowing mood and a sense of wonderment.

As much as Ellen Johnson's memoirs were written in periods of great physical pain, they never mention suffering, even for a moment. In spite of the many illnesses and operations that plagued her last twenty years, she never lost her incredible optimism and enjoyment of life. I am certain that the readers of these stories will have as much fun as she had living them, whether they knew Ellen or not. She had the talent to make life seem truly worthwhile for everybody, even after her death.

FRAGMENTS

I

In an old brownstone on Fifty-second Street just off Fifth Avenue (now a part of Rockefeller Center) I was spending the fall of 1943 in a friend's lovely apartment free of charge on condition that I share it with the owner's great dane. A gorgeous, sweet-tempered creature, she was a joy to walk with in Central Park each day, where she often exchanged greetings with an elegant deer led—or followed—on a leash by a little old lady. Although it was illegal to let dogs run free in the Park, Margot, the owner, had insisted that I do so. Of course I got arrested and had to go to court, where for a whole morning I waited my turn among a crowd of junkies and prostitutes.

I had taken the semester off from my job as art librarian at Oberlin to spend a real block of time in the museums and galleries and to study portrait painting with Anne Goldwaite who taught at the Art Students League. Hazel King, the Oberlin Art Museum's first curator, had suggested that I keep my eyes open for anything that seemed desirable to recommend for the Purchase Committee's consideration. I had often accompanied Mrs. King on weekend study trips to New York travelling by train over Friday and Sunday nights. She always took a sleeper, but on a salary of one hundred dollars a month, I sat up in the day coach and watched people between catnaps. It was almost as good as the New York subway.

Having been brought up in Europe following the seasons at all the appropriate spas and cities, Mrs. King was an elegant, gentle lady who was perfectly at home in the hushed, velvet-hung rooms of the major New York galleries. Martin Jennings at Knoedler's was especially devoted to her and made it possible for Oberlin, with its poverty-level budget, to acquire at ridiculously low prices many treasures including Chardin's *Côte de Boeuf* and Monet's *Le Jardin de l'Infante*. As the museum's travel funds were practically non-existent, she too used her own hard-earned money, so we stayed in a cheap hotel on West Forty-eighth Street until one time Martin Jennings delicately suggested that a better address would prove rewarding in the art world market. Surprisingly, we found that several excellent hotels, including the grand old Gotham on the corner of Fifty-fifth and Fifth Avenue, extended large academic discounts, a happy situation that held till about 1960.

I saw a good deal of Martin Jennings that fall of 1943 and among the art works he showed me was a handsome portrait by the youthful Van Dyck. I sent Mrs. King a photograph of it and she reported that when she showed it to the Purchase Committee, the College president, Ernest Wilkings declared, "Certainly not! The students are degenerate enough without our exhibiting for their benefit the image of such a dissolute character." Nonetheless, the committee voted to have the painting sent out on approval and sometime later, when the President saw the actual portrait he exclaimed, "What an extraordinary artist, to have painted with such understanding the face of a man who has lived."

Another art friend, Ted Schempp, who had graduated from Oberlin a few years before I did, had become a dealer who lived in France but frequently travelled to the States, bringing with him fine examples of the current School of Paris. As he was in New York for some time that year of the war, he let me have two paintings of my choice to hang in the apartment on West Fifty-second. Thus I had the incredible good fortune to live for several weeks with Picasso's *Verre d'Absinthe*, a classic analytic Cubist work, on one wall, with its antithesis, a 1913-14 Kadinsky, churning up the space across from it. Of course I sent photographs to Oberlin and the predominantly conservative committee rejected the Kandinsky, as was to be expected but, as was certainly not, they snatched up the Picasso (at a price so low I should think the very card in the registrar's file would turn pink at the figure). Those were the golden days long before the 1980's pyrotechnics took off in the auction houses.

A couple of Oberlin professor friends, Andrew and Marjorie Lawson Hoover, were in New York briefly while Andy was on furlough. Knowing their interest in art, I introduced them to Ted Schempp and they bought a stunning water color from Picasso's *Les Demoiselles d'Avignon* group. We celebrated hugely, but the check had to be cancelled the next day because Marjorie was taken to the hospital with pneumonia. I think it was the Tannhauser collection where their "pneumonia Picasso" ended up.

Mrs. King had asked me to see if I could find a good American water color for five hundred and fifty dollars, the total of a specific acquisition fund that was directly available to her. "Of course," she said, "it would be lovely if the museum could get a Marin, but with the prices he now commands, I know that's way out of the question." Still,

I thought there's no harm in trying and anyway I wanted to see what was up there at Alfred Stieglitz's 509 Madison Avenue gallery. Nothing, it turned out. The morning I went all the walls were freshly painted grey; but that light, dove color was of such a delicate, translucent depth that stepping into the room was like entering a realm of unearthly pure, unlimited space. That effect must be something like what Barnett Newman had in mind when, in June 1965, he proclaimed, "I wish to declare space" (Sao Paulo, VIII Bienal).

Involuntarily I exclaimed to a little old man who had come shuffling in, "It's so beautiful without anything in it!"

He said, "O, you like it this way? Well then, why don't you come talk with me?" He led me to a little office with a huge black leather chaise-longue type couch (like my father used to doze on after Sunday dinner) and said, "I hope you don't mind if I rest while we chat?" I realized it wasn't a janitor as I had first assumed.

For three hours Mr. Stieglitz talked to me about art, most memorably about photography and what his own work meant to him. He couldn't have found a more totally absorbed listener. Aside from everything else, I was very much involved with photography at that time, having set up a dark room for myself, in an unused subterranean area of the art building in Oberlin, where I developed, printed and enlarged photographs, fussing around with dodging and other such old-fashioned, time-consuming but enjoyable means. Stieglitz illustrated the uniqueness of a print by relating (surely not for the first nor last time) what he said when asked for a duplicate print: "Have you ever made love to someone with absolutely everything in you? Well, don't ask me to make six copies!"

Toward the end of our session he remarked, "So you'd like to have a Marin water color for Oberlin?"

"Well, yes, of course, but we don't have enough money."

"How much do you have?"

"Only five hundred and fifty dollars."

"All right then, that's the price." Whereupon he took me to a small room filled with drawers and boxes of Marin water colors and said, "Pick out whatever you want," and left.

After a glorious hour or more of looking through a whole Marin retrospective, I had put aside six to choose from. Just then Georgia O'Keeffe burst in with, "What are you doing?!"

"Mr. Stieglitz said I could select one for an Oberlin Museum

John Marin, *Small Point, Maine*, 1915, watercolor, 14″ × 16½″, Allen Memorial Art Museum, Oberlin College, Oberlin, OH, Friends of Art Fund, 1944

purchase."

"At what price?" I told her, and she rushed across to Mr. Stieglitz's room almost screaming, "Are you out of your mind?" When she returned, she took my first choice and said, "That's too important. You can't have that! Nor that—nor that . . . !"

When she got to my fifth choice, he called, in no uncertain terms, "Georgia, let her have *one* of her choices!" That's how we got our Marin—and how I met Georgia O'Keeffe.

Another art acquaintance from my 1943 New York semester was Alexander Archipenko with whom Margot was living at the time, which explains why she wanted to have someone occupy her apartment and befriend the great dane. When I first met Archipenko on a weekend visit at their place in Woodstock, instead of the usual greeting, he ran his hand down the side of my body and purred, "Vot a bee-*you*-tifull line!" Par for the course with Archi, as I discovered on a few later occasions when I went to see them in one of those bathtub-in-the-kitchen apartments at the edge of Hell's Kitchen. He was so delighted with some portrait photographs I made of Margot that he gave me a large, powerful drawing called *The Rape*, which I've now given to the Museum. (I seemed to have a kind of knack with portrait photography and painting, and I think I might have become professional at it if I hadn't discovered that I loved teaching.)

Those months in New York were not all art encounters and events. I had a personal life too, which included fending off an attractive but tediously ardent, and married, composer on leave from Oberlin, and becoming engaged to Margot's brother. It was delightful going with Bernon to elegant restaurants and night clubs and concerts. I particularly remember a superb chamber music series. With others I went to jazz concerts; I'll never forget the blind black pianist Art Tatum. (I also remember that I was wearing my hair in a chignon that year, often with a camellia in it.) It was all very glamorous. But when Bernon visited me in my own environment in Oberlin and could only talk about his yacht and such self-indulgent trivialities while other men I liked, and one I loved, were out risking their lives in the war, his charm immediately evaporated and I broke the engagement. But enough of such adventures that don't belong in the kind of recollections I'm trying to pull up now.

While I was a student the last thing I thought I wanted to be was a teacher. My major was English literature until my advisor, Mrs.

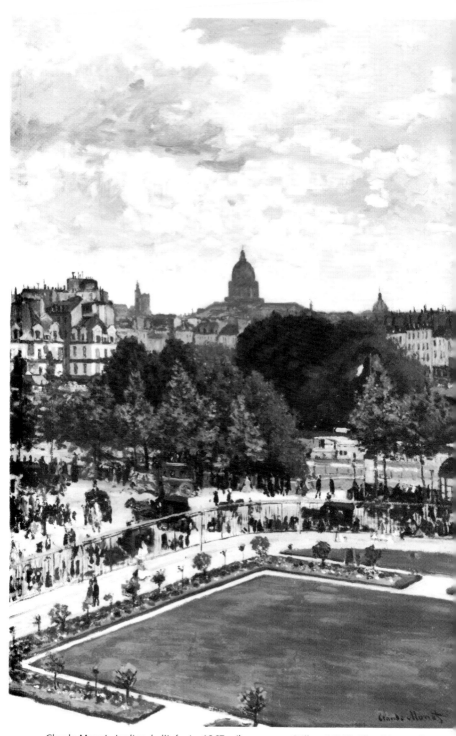

Claude Monet, *Jardins de l'Infante,* 1867, oil on canvas, 36″ × 24½″, Allen Memorial
Art Museum, Oberlin College, Oberlin, OH, R.T. Miller Jr. Fund, 1948

Alexander Archipenko and his studio, photographed by Ellen Johnson, New York, 1943

Lampson (bless her name!), said, "You are enjoying that course in Renaissance art so much, why don't you major in art history?" Having entered college in the fall of 1929 (my father, like so many others, lost everything but the roof over his head in the crash), it had not occurred to me that one could major in a subject that was just pure joy.

At first I was surprised to discover that the study of the history of art made all the other subjects more engrossing and connected. But before completing the M.A. in 1935, I understood that basic truth of our profession: art reflects, while it illuminates, all areas of a given civilization at a given time. To teach art history adequately, then, is a goal that only a few minds are great enough to achieve. The rest of us can only keep struggling, hoping to master some small area of learning, but never quite making it. Yet, if one really likes to teach, it is with a constant prickling of guilt that one gives the appearance of full command.

In spite of the Great Depression, I managed to study at Oberlin for six years by several means: scholarship aid (the maximum was fifty percent of tuition, then one hundred and fifty dollars a year; in 1991 it is over sixteen thousand dollars!); the sacrifices of my parents and sister Elva; and the miracle of Franklin Delano Roosevelt's National Youth Administration of his WPA, which gave me thirty cents an hour for work in the art department and museum, primarily in the art library. I actually became the full-time acting librarian, during the absence of the regular librarian, for the whole of my second graduate year, while I used evenings and Sundays to write my M.A. thesis and prepare for the three-day written and one-day oral examination then required for the art history M.A. degree. Thereafter, the summer of 1935, I went to Paris (on the return maiden voyage of the famous Normandie) to study at the Sorbonne on a fellowship from the Institute of International Education. At the end of the summer program, which concluded with an entirely oral exam, I travelled to the homeland of my parents, Sweden.

Returning to the States in the fall of 1935, I found the Depression still in full sway. There were no jobs to be had, so I got a fellowship for another graduate year at Oberlin, this time studying exclusively in the studio section of the department. I have always considered it most desirable, really essential, for an art historian to have some practical familiarity with the material she or he investigates.

When at the close of that academic year I was offered a job in the

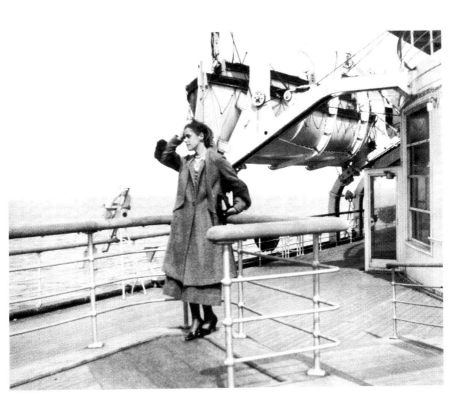

above: Ellen Johnson on the return maiden voyage of the *Normandie*, en route to Paris with a fellowship of the Institute of International Education, summer 1935

right: Ellen Johnson, art librarian and instructor of fine art at Oberlin College, passport photograph for her trip to Sweden with a year's fellowship from the American Scandinavian Foundation, August 1946

Educational Department of the Toledo Museum of Art, I could hardly believe my good fortune. I went in early June to settle details and make living arrangements. I found a simple one-room, bath and kitchen apartment a few blocks from the museum and paid the required rent to hold it through the summer. The day I arrived in the fall, I cleaned and scrubbed every inch of the place and everything in it till late at night when I turned out the lights and fell into bed—and into a state of terror.

Although a sturdy, sensible sort of person, I was assailed by an atmosphere, indeed an actual physical presence, of something fearful or evil. I couldn't possibly stay there another day. Poor as I was, I forfeited the advance rent and found a private home that, like so many others in the Depression, took paying guests. Later that day I was not surprised to learn from my superior at the museum that, had she known of my choosing that apartment, she would never have allowed me to stay in the room where a famous gangster had holed up and been killed. That was my most violent experience of a strange power that a place has to retain and transmit an aura emanating from the people and events in its history.

My duties at the museum, besides giving gallery talks and other such docent work, entailed ordering books and keeping some kind of order in the library, housed between the front entrance and the Educational Department. I soon found that the library needed a serious cataloguing. After studying the Oberlin, Cleveland, and Metropolitan museum systems, I fully organized the Toledo museum's library and its card catalogue, whereupon I was given the title of Art Librarian, the first of a long line of through-the-back-door professional moves.

The second such new direction also occurred at Toledo. The Director, Blakemore Godwin, called me into his office one day, always a terrifying experience because he sat, looking as impassive as stone, way at the end of a long, large office, past the desk of the President, sweet "Uncle Billy" Gosline. Mr. Godwin addressed me impersonally, but not unpleasantly, "What do you think of that marble head on the mantle?"

"It's lovely. It looks Praxitelean."

"Put down your impressions at home tonight and bring them in to me tomorrow."

A few months later as I was looking through incoming periodicals, there was "In the Style of Praxiteles" in the *Magazine of Art*, August

1937. My first article! And I didn't even know I was writing it.

The Toledo job, with the wide range of opportunities it offered me, was not only an invaluable experience professionally, but a very agreeable one socially. The staff was most congenial. We came together for special occasions, all hundred of us, in the huge empty future gallery space where we feasted, danced, and once even roller-skated. At one Christmas party the director's present was a live chicken that broke down even his reserve in the general merriment.

Those years in Toledo brought me several very interesting and stimulating friends, among them the person in charge of the performing arts presented in the peristyle, a glorious space shaped and lighted like an ancient theater under a night blue Aegean sky. One of George Furman's most enjoyable responsibilities was seeing to and entertaining the Ballet Russe during their annual appearance. Thus I met the dancers when he entertained them in his home and got to know some of them who invited me to stand in the wings at performances.

Through an Antioch College semester-on-the-job program I made friends with a couple of those students who came to the Toledo Museum, where they were given latitude to develop in their own way. One special friend, Art Lithgow, made the most of that opportunity by writing plays about works in the museum and presenting them over the radio. Particularly memorable was the way Lithgow made Ralph Blakelock, an American 19th century painter that I hadn't paid much attention to, come alive for me in his enthralling dramatization.

It was also in Toledo that I met Gustaf Munthe who had come over in 1938 with the big Swedish art exhibition celebrating the Tercentenary of Swedish settling in Delaware. As the show was in Toledo for a considerable time we saw a good deal of each other, and thereafter on many occasions in Stockholm when he and his equally charming wife entertained me in their home, where I met several other interesting Swedes, including a couple who became close friends. In those days one dressed for dinner and, even if there were as few as six or eight guests, there would be a chart in the entrance hall indicating one's place at table and for what lady each man would be the *bords kavaljer* (table partner).

Best of all, in some circles, there would nearly always be dancing after dinner. Even in Oberlin before World War II we wore evening clothes at concerts, visiting art lectures, and many other ordinary

occasions. In retrospect it seems a far less hurried and harassed life, and yet we seemed to accomplish just as much if not, as I sometimes suspect, more.

Back to Toledo in 1938: Gustaf Munthe took me along to Cranbrook to visit his friend Carl Milles who invited me to return, which I did one very hot day. Sitting with him and Mrs. Milles in their Saarinen-designed living quarters with the sun streaming in, and looking out at the Milles fountain, I remarked casually, "How lovely it would be to splash around with your Nereids in that cool water."

Mr. Milles: "You vant to svim? I vill find a suit for you."

Demur as I would, he called students till he located one. How many times, especially in hot concrete cities, one has wished, "If only I could jump into that fountain!" How undreamed-of to actually do it, and at the invitation of the artist.

Another Toledo friend was a young man from one of the big rubber families. If, as was then gossiped, he was hired in the expectation of bringing with him and attracting wealthy contacts for the museum, the administration was sorely disappointed because no one could have been less inclined to court social position or money. His best friend was the ink-stained printer at the museum, and when he sometimes took me to the movies, he'd suggest we walk two or three blocks toward town before boarding the street car because the fare decreased from ten to five cents at that point. Apparently he too knew well what money meant in those days.

Whenever I recall working in Toledo in the grip of the Depression I feel again the city's strange silence and grieve for the jobless, homeless, ill-clothed, unfed, hopeless people who seemed to have had their very voices taken from them. Out of that dirty grey poverty the Museum of Art rose, in its pure white brilliance, like a dream of classic perfection and ease. In spite of the museum's justly celebrated program of public education, it felt to me shockingly isolated from the city. For all the pleasantness of working there, I was constantly troubled by the violent contrast and a sense of unreality in the situation. When I was invited back to Oberlin as art librarian, in the fall of 1939, I was not sorry to leave and very happy to return to a place that, in spite of the alleged remoteness of an academic community, was far more real to me in every way.

When I was preparing to leave Toledo, Uncle Billy Gosline, being one of those wise and blessed wealthy people who prefer to give their

above: Pojke and the roadster, Oberlin, summer 1940; photo: Ellen Johnson

right: Ellen Johnson, librarian and docent, Toledo Museum of Art, c. 1937

money during their lifetime so they can have the joy of seeing the good it does, said, "In a country place like Oberlin you will need a car, so go find a good used one." That I did, for seven hundred and fifty dollars, a gorgeous translucent blue 1938 Chrysler convertible with a rumble seat. Uncle Billy had given me six hundred dollars. The two people to whose spacious apartment I was moving—Dorothy Daub, Open Shelf Room librarian and an Oberlin legend, and Kathryn Coates, Spanish and French teacher and sister of my college classmate Ruth Coates Roush—each contributed seventy-five dollars, and the Chrysler became the house car. I've heard it's now in an antique car museum in Kansas or somewhere. What fun it was to ride around in with our wire-haired terrier, Pojke, standing nobly on the canvas top, which he destroyed two or three times and my nice insurance man replaced, claiming it was an "act of God."

I started as art librarian at Oberlin in September 1939. Soon after the first semester got under way, one of the art history professors became too ill to continue teaching and I was asked, as an emergency measure, to fill in for him. I took over his Northern Painting and Renaissance Architecture courses, the latter blessedly only for a short time as I couldn't take to it the way I did to Dutch, Flemish and German painting of the Renaissance and Baroque.

Thus it was entirely by accident that I discovered how much I loved teaching. I shouldn't have been surprised; as a teenager I had hoped to become an evangelist and I have certainly spread the gospel of art all my working life. I was thinking recently how my lectures so often seem to end up like sermons.

The students in that first course petitioned the art department chairman and the dean and president of the College to appoint me to the faculty, which was totally out of the question at that time, for budgetary if no other reasons. But having made that momentous step through another back door, and not about to let a little thing like money keep me from going on, I offered to teach the students in my free time without salary, if they were willing to study without academic credit. Beginning in 1940 I taught a museum course (there were all those real works of art and all those art history students, so why not put them together to good use?) and another course in contemporary art, having first sought permission from Jessie Trefethen, a studio teacher who also taught modern painting. Though not scholarly, hers was a marvelous course and the only one I ever had in that subject. She

stopped at Picasso's blue period, calling it "the cult of death." But, being as fine a person as she was a teacher, she didn't mind at all having a young upstart offer the students the newer, more heady stuff. I still have the grade books I kept for those two unofficial courses, precursors of the present ExCo (Experimental College) program at Oberlin.

After two or three years the College decided to give me a part-time teaching appointment. From 1945 to 1947 my time was apportioned as six-elevenths librarian and five-elevenths faculty. (More than half time faculty would have entailed expensive fringe benefits.)

There was always room to branch out in Oberlin. Early on in my library days, in 1940, I believe, it occurred to me that if students could have works of art in their dormitory rooms it would not only develop their aesthetic sensibilities but might encourage ordered thinking and discrimination even in other areas of their lives (the evangelist syndrome again). For funds to start such a project I approached the department chairman, but unhappily Clarence Ward was away that year so the answer was "No." I also got a negative response from the Head Librarian of the College. Then, with an abundance of youthful nerve, I went to President, Ernest Wilkins, and that forbidding-looking, distinguished Petrarch and Dante scholar said, "It's a splendid idea. If you go to the library and look at my book of essays, you'll find that I even proposed a not unrelated project, and for much the same reasons as yours. I'll see that you get funds to initiate the program."

I was given seven hundred dollars to purchase and frame reproductions of art masterpieces. So began one of the earliest, if not the first, college art rental collections in the country. Gradually, over the next decades, the reproductions were replaced completely by originals. I was never given, and never requested any further appropriation. That whole remarkable collection of more than three hundred original works of art was acquired solely from the rental income. For many years at twenty-five cents, and even now only five dollars, a student can hang in his or her room for a whole semester Toulouse-Lautrec's *Jane Avril Dancing*, a watercolor by Diebenkorn, a drawing by Eva Hesse, or a print by Matisse, Johns, Dine, or one of five by Picasso. With such limited funds, I was able to make those and many other comparable acquisitions by scrounging around for half a century in galleries and studios throughout our country and Europe,

and from Teheran to the Australian outback. It was easy to do because I most especially enjoy talking with artists and have always found them extraordinarily generous.

Artists are invariably amazed and thrilled to hear how Oberlin students (not just art majors, but physicists, historians, pianists and football players) stand in line for hours before rental begins in order to get one of their choices from the collection, which is put on view for a couple of days prior to distribution. Some students are so filled with desire that they camp out all night, even in February in Ohio. Of course that's partly a lark and a challenge, but the fact that there has been so astonishingly little damage, and then only to frames, during all those years attests to the students' serious interest and appreciation. Many artists are so touched by the student attitude that not only do they make sizeable reductions or even donations, but on some occasions make it possible for the museum to acquire major works for the permanent collection. That's how Barnett Newman's *Onement IV* of 1949 came to Oberlin.

Another of my early ventures was purely for entertainment. I organized Oberlin's first film series (there must be close to a dozen now). With the proceeds of an annual two-dollar membership fee I rented as many films as could be had for that amount, never less than eight, often silent classics from the Museum of Modern Art, spiced up by the antics of a conservatory student on an old upright piano.

Of a somewhat more serious nature was another project I started in the early 1940's. I got the idea one day while browsing in Wittenborn's book shop in New York when the owner showed me some Rouault prints (engravings and color etchings from a publication of *The Passion*). I immediately thought of the two blank walls in the art library on which I put up reproductions of material related to various class studies, as well as exhibitions organized by students in the "ExCo" museum course. I asked George Wittenborn if I could borrow some of the Rouaults for an exhibition in the art library, and perhaps even sell a few of them. The subject of *The Passion* was particularly appropriate because, as I recall, it was the Lenten season. He was most obliging, and was amazed at the response of students, faculty and townspeople, several of whom took advantage of the opportunity to purchase original works of art at extremely low prices. There may also have been prints from another Rouault work, illustrations to *Père Ubu*.

I myself purchased one of the color etchings from *The Passion* for

about fifty dollars. I *think* it was my first acquisition, but could I really have been in Paris the whole summer of 1935 rummaging, in my spare time, through all those print dealers' cabinets without buying one single little thing? Of course I was poor. I remember drinking hot water with the juice of a lemon in it for breakfast because I couldn't afford both fruit and coffee. (Surely I can't have used all of what little spending money I had on perfume and pastries!) That first attempt at a sales exhibition was so successful that it was repeated and soon grew into the museum's annual, sometimes biennial, Purchase Show, usually held before Christmas vacation, and only recently given up, because prices had become too high for the Oberlin public.

The freedom to develop one's own interests that I enjoyed in the art library extended also to the classroom. Ever since 1935, when I first visited Sweden after the summer's study in Paris, I was overwhelmed by a desire—more than that, an actual *need*—to learn about the art of my parents' homeland. I shall never forget the shock of belonging that surged through me down to the bottom of my toes when a newspaper vendor in Malmö boarded the train for Stockholm and called "Tidningar!" Even now I can still hear in my mind's ear the very Swedish cadence in that word and feel in my body an echo of the vibrations it aroused. I recognized on some deep atavistic level that this was home, not just of my parents, but of their parents, and parents' parents back to the beginnings of human time in the North. (On occasion I have experienced a somewhat similar wave of recognition in Greece, which is not so surprising as it might seem, given the visual evidence, including runic inscriptions on monuments there as well as in the North and numerous finds of Mycenean coins in Sweden, that attests to the sea-faring Swedish tribes' forays and sojourns in "Grekland.")

To begin learning about the art of Sweden, I spent the summer of 1938 there on a research grant from Oberlin College. Although everyone I talked with professionally knew English, I realized that I'd need competence in the language for any serious study. As I was the youngest of five children, less Swedish was spoken at home during my childhood than had been earlier. In 1940 I tried to locate a Swedish language course available in summer school. The only one I discovered at the time was at the University of Washington in Seattle where, on the first day of classes, the professor (in a relaxed summer mood perhaps) decided to offer the literature course in translation rather than

in Swedish, and, because "grammar is such a bore," he conducted that course only once a week for the four week session. Thus I travelled four thousand miles for four hours of instruction in Swedish grammar. But at least I did acquire the basic books to work on my own.

In 1945 I attended a six-week program at North Park College in Chicago where Swedish was taught according to the system developed by the military early in World War II as the only way to master a language quickly: complete immersion in it with absolutely no English allowed at all. There were about thirty or so in the North Park program, speaking, reading, writing, listening to and occasionally giving lectures in Swedish.

I had some familiarity with the language having attended the Swedish Lutheran Church, participated in the service and, above all, listened to Reverend Jacobson intone its beautiful language. We were taught manners in Swedish; there were always Swedish newspapers in the house, not to mention a large framed picture of the royal family of Sweden in the dining room (for many years I thought it was our family). My mother loved to recite her favorite Swedish poems; and my father, who had a lovely voice, always sang in his native tongue, most memorably for me the bitter-sweet eighteenth-century art songs of Bellman, musician to King Gustav III, and beloved of all Swedes. I grew up hearing and absorbing the peculiarly Swedish intonation of my parents and their friends, even when speaking English. Thus I had a natural speech rhythm and accent (my "l"s and "r"s, for example—especially revealing of a foreigner—were distinctly Swedish).

After the summer language course I felt sufficiently competent to undertake serious study of art in Sweden. Consequently, on a fellowship from the American Scandinavian Foundation (in whose *Review* I had published a few articles), I spent the academic year and summers of 1946-47 taking courses on Scandinavian art at the universities of Stockholm and Uppsala and, on my own, studying, taking slides and discussing the work in public and private collections, studios, galleries, and museums, as well as in churches and other monuments throughout the North. Everyone was uncommonly friendly and helpful not only at work but in their homes: professors, artists, and museum curators, guards and directors—among them Sigurd Curman, Director of the Museum of National Antiquities, whose many kindnesses included taking me on a private study tour of several medieval churches that were in the process of being repaired or

restored under his direction. On one occasion I had the amazing experience of crawling under the roof, which was being repaired, to examine the original wooden construction decorated with Romanesque murals, while I walked on top of the brick vaults that were thrown up in the Gothic period below the wood. Only then, through my feet, did I understand something that had always baffled me: how Gothic vaults were constructed.

That first year after the war Stockholm hosted two very special, large exhibitions: a blockbuster of Pan-Scandinavian arts and crafts and a superb, comprehensive selection of the work of Munch. I became so immersed in Munch's Northern melancholy that I wrote an article to get it out of my system. Finishing that piece was like emerging from a dark cave into the blessed light of day. Published in the *Art Quarterly*, Spring, 1947, it was one of, if not the first article on Munch in an American art journal. I say that with less pride than chagrin for what now seems naive.

Returning to Oberlin I eagerly tackled the Scandinavian literature I had assembled. At that time there was virtually nothing available in English on Scandinavian art (there's precious little even now), but with knowledge of Swedish and a slower-going grasp of Danish and Norwegian, I felt ready by the fall of 1948 to begin teaching a course in Scandinavian, primarily Swedish art. Surveying a broad range, from the prehistoric period to the present, it was the only course on the history of Scandinavian art in the country and continued to be so until a student of mine, when I was visiting professor at the University of Wisconsin in 1950, became so interested that he changed his doctoral thesis from a Scandinavian language subject to one in art, and eventually initiated his own course at the University of Minnesota.

In 1947 I was appointed to a full-time faculty position, even at that time an exception, an impossibility now, without the Ph.D. I did start proceedings toward the doctor's degree at Columbia University, but in spite of Professor Meyer Schapiro's support and attempts to transfer of credit for work I'd done at other institutions, the administration did not lessen their three-year residence requirement. Both Schapiro and my distinguished colleague, Wolf Stechow, said it would be a frightful waste of time to give up three years in proving what I'd already demonstrated: a general command of the discipline and ability to contribute in scholarly discourse.

Like the rest of the faculty at that time, I taught five courses,

fifteen hours, each semester. The normal load now is a total of five courses a *year*. Still, the students, in spite of their teachers' heavy schedules, seemed to learn as much. Their papers required far less of an instructor's time in correcting faulty English composition than they do today. It's difficult to pinpoint why, in spite of what would now seem an impossible teaching load, we earlier teachers still managed to have time for our own productive work. Only the most obvious explanations suggest themselves. There were far fewer distractions: no television; no visiting entertainers (only "serious" music and the occasional imported band, which, like our campus small band for the daily evening "rec," was *for dancing*); very few films but many guest lectures (well attended); Saturday classes; compulsory noon chapel or assembly (at which student attendance was taken and the faculty were seated in full view behind the speaker); and a stimulating faculty Philologue club. There were far fewer grants available, less frequent leaves, and not nearly so much time wasted preparing endless reports and annual evaluations of oneself and, most harrowing task, of all one's colleagues.

FRAGMENTS
II

When Robert Motherwell was in Oberlin for two weeks in April 1952 to conduct the Baldwin Seminar, he chose as his official topic, "The Ideas and Rejections of Modern Art: Preface." What he really talked about was the New York School and, most particularly, what was soon to be known as "Action Painting," or more generally "Abstract Expressionism."

In the early 1950's artists were not rushing about so much as they are now from campus to campus, giving a one-day workshop here and a talk on their own work there. Extraordinary as it was in 1952 for Oberlin to invite an artist, not an art historian, to give a lecture (let alone ten of them), it was more remarkable still for the seminarian to choose to present the genesis and early development of a new kind of painting when it was still in the process of becoming, and to do so with scrupulous scholarly care, precise organization, and attractive, even elegant language. Young Bob Motherwell was clearly the philosopher of the group. Concurrently with the seminar the museum had organized an exhibition, a little retrospective really, of Motherwell's work, including several pieces from the *Spanish Elegy* series, three or four sketches for his Milburn Synagogue mural, and a few collages—the genre in which he so obviously seemed, as he was often called, "the most French of the American school."

It wasn't long before the exciting discussions at the Club and all the other meeting places of the group began to be written up and widely known about. But at that time it was all very new to our students—except for those who had been associated with another New York painter, Jeanne Miles, who replaced one of the Oberlin teachers on leave in 1951-52. She talked a lot about the Club and the Cedar Street Bar and other favorite haunts of the group. She was a fascinating artist with a pronounced interest in astrology and cosmology; a mystic aura continued to imbue her elegant abstract paintings that I saw from time to time over the years.

I personally profited also from my friendship with a former student, Budd Hopkins, then a striving artist and assistant at Eleanor Poindexter's gallery, now a well-known painter. Actually it was he who first took me to the Cedar Street Bar with its toilet door still off the hinges from one of Jackson Pollock's more dramatic bouts. I met and

above: Franz Kline, *Untitled*, 1953, oil on paper, 8½" × 10$^{7}/_{8}$", Estate of Ellen H. Johnson; right: Barnett Newman, *Onement IV*, 1949, oil on canvas, 38" × 43½", Ruth C. Roush Fund for Contemporary Art, N.E.A. Museum Purchase Plan and anonymous donor, 1969, reproduced with permission of Annalee Newman; Allen Memorial Art Museum, Oberlin College, Oberlin, OH

talked with that legendary figure only once, at Sidney Janis' gallery (or was it at Betty Parsons'?), where he seemed equally at ease in a business suit and in friendly, civilized conversation.

Subsequently I did get to know Pollock's wife, Lee Krasner, quite well. From Krasner I learned many revealing things about Pollock, one especially touching: that he kept his books in drawers because one's reading is a private thing, and another far less surprising—while he painted in the big barn studio, Krasner worked in a little upstairs bedroom.

The story I most enjoyed from the Cedar Bar days was one of Franz Kline's that's surely a classic by now. It was at the time of one of Betty Parsons' early shows of Barnett Newman's paintings, which someone at the Bar was ridiculing as absolutely simple, nothing but a stripe down the middle of a big empty space.

Kline asked, "Is the stripe always the same color?"

"No."

"The same size?"

"No, some are wider than others."

"Are all the backgrounds the same color?"

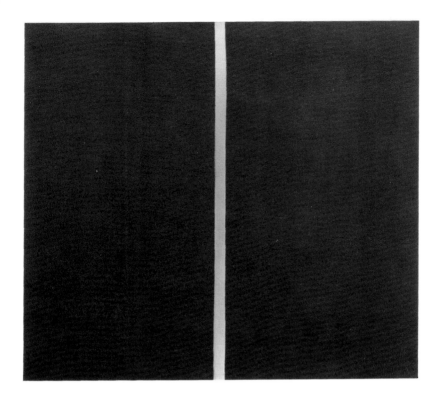

"No, some are red, some blue, some black."

"Is the stripe always in the middle?"

"No, sometimes to the side."

"Is there always just one stripe?"

"No, some canvases have two or three stripes."

"Are they equidistant from each other?"

"No, the width between them varies."

"Sounds very complicated to me!"

Through Budd Hopkins I was able to buy two of Franz Kline's marvelous little in size, large in scale, oil paintings on paper, at fifty dollars for one and one hundred dollars for the other, for the Oberlin Museum Rental Collection and for myself. I mention price to explain how it was possible to make such acquisitions with extremely limited funds. (My salary for the year 1952-53, for example, was four thousand three hundred and seventy dollars.)

The most expensive thing I bought for myself in those years was from the Poindexter Gallery, a large Diebenkorn painting, *Berkeley #42*, of 1955. I loved that painting. I knew every single fraction of an inch of its extraordinarily varied surface: brush and knife strokes, scumbles, drags, drips and scratches. I had recommended to the

Oberlin Museum that they acquire a Diebenkorn which they did a little later, *Woman by a Large Window* of 1957. When I bought (started to buy) the Frank Lloyd Wright House in 1968, I found that my beautiful Diebenkorn painting was totally out of scale; there wasn't a place in the house that could take it. The living room fireplace wall might have been large enough, but that area is such beautiful architectural sculpture, or sculptural architecture (almost one and the same thing for many artists today), that I couldn't for a moment think of hanging anything there. Consequently I offered the painting to the Oberlin Museum, saying I'd like it to be there but if not, I'd sell it. The then director said he thought one Diebenkorn was enough, so I sold it in 1968 to the Cleveland Museum for sixty-five hundred dollars. I knew I could have gotten more for it (as indeed the curator himself told me later), but that seemed enough of a mark-up from the six hundred and seventy-five dollars I had paid for it. Most important, it was in a public collection nearby so I could (and can) see it often.

That's the only work of art I ever sold and it was a horrible feeling; but I used the money toward the down-payment on the Frank Lloyd Wright house, which I knew would take an enormous amount of money to restore. Thus, ultimately, the loss of the Diebenkorn helped to insure for Oberlin College the acquisition of another work of art, a very useful as well as beautiful one.

Several years before selling the painting, I published an article in the *Allen Memorial Art Museum Bulletin* (XVI, 1958-59, 18-23) comparing the abstract but evocative *Berkeley* landscape with the museum's figurative painting, *Woman by a Large Window*. In preparing the article, I corresponded with Diebenkorn. He was not only very generous in writing, but he also gave me a drawing for the *Woman by a Large Window*, which I turned over to the museum. In 1958 I was lucky enough to find a gem of a Diebenkorn watercolor (of 1954, with colored pencil, and a drawing on the verso) which I let Oberlin's rental collection have (I always wanted the best for the students). It wasn't until 1970 that I actually met Richard Diebenkorn, in Houston where he was teaching and I happened to be lecturing. What a joy it was to find in him the steady accord between artist, teacher and person that one would expect or hope for from his serene, sun-swept and disciplined painting.

Probably the most serene landscape painting I have ever seen is John Frederick Kensett's *Lake George*. The first time I saw that spacious

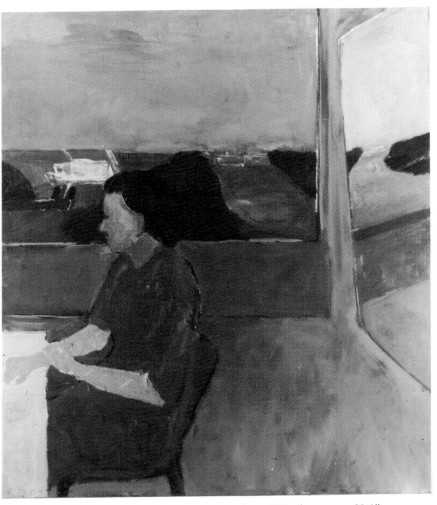

Richard Diebenkorn, *Woman by a Large Window*, 1957, oil on canvas, 80½"
× 74", Allen Memorial Art Museum, Oberlin College, Oberlin, OH, R. T.
Miller, Jr. Fund, 1958

painting, in one of the densely packed American galleries at the Metropolitan in the early 1950's, it fastened itself deep in my perceptive mind, where I can still turn to it for a quieting moment. Unlike Diebenkorn's abstractions that nonetheless evoke the general quality of nature in a given area, Kensett's *Lake George* is that place and none other. The soft blue and dull gold of the painting's water, mountain and sky are quietly luminous as though lit from deeply below their surfaces.

All I knew about Kensett, and I soon discovered pretty much all anyone knew about him, was that he was vaguely associated with the Hudson River School, was highly regarded in his time, was one of the founders of the Metropolitan Museum of Art, was seriously active in all the major national art organizations and committees, and died in 1872. Until the middle of the twentieth century that was the limit of general knowledge about the artist at whose funeral services were assembled all the great figures in the American art world.

Kensett's *Lake George* meant so much to me that I just had to see more of his work and find out everything I could about him. I had a grand time digging in historical societies, museums, libraries, private collections, family records, even the files of the Greenwood cemetery in Brooklyn, one source leading to another, as the researcher always hopes will happen. The New York Public Library's clipping file was a veritable treasure trove of priceless material, including such primary documents as Kensett's journal (subsequently transferred to the Frick Art Reference Library) and the only known priced sales catalogue of the six-session sale of works in his collection at the time of his death. Furthermore, I had the extraordinary good fortune to get to know Kensett's grand nephew, J.R. Kellogg, who had a superb collection of documentary material, several boxes of which, in his great interest and generosity, he actually brought to me to have at hand for several days in the apartment I was subletting in Manhattan about 1955-56: letters, photographs (some on visiting cards), notes, sketches, lists and prices of paintings sold, and many other invaluable sources of information. The scanty references to Kensett in the literature put his birth sometimes at 1816 and others at 1818. Although even a passport gave it as 1818, I was able eventually to establish it conclusively at 1816.

A particularly touching piece of evidence led towards the dating of a small oil painting, *The Temple of Neptune, Paestum*, in the Oberlin collection. A little wild flower was lovingly preserved in a sheet of

paper folded into a teeny envelope inscribed "Paestum, Monday May 3, 1847, Temple of Neptune." The picture, which seems more like his oil sketches than his finished paintings, must have been painted at least quite soon after that sweetly remembered day at Paestum. There were many other interesting discoveries and adventures, some of which are referred to in the article that resulted from my studies, "Kensett Revisited," *Art Quarterly*, XX, 1957, 71-92.

As that was the first serious publication on Kensett, it led to further information coming my way for years, often of course in the form of requests for an opinion on this or that picture; but gradually it petered out as other scholars produced important work on Kensett (most notably John K. Howat's catalogue of the circulating Kensett exhibition in 1968), and as American 19th century art in general became, happily, a major field of study—and, not so happily, of investment. A particularly memorable request came from the director of an historical society in New York state saying that he had come upon a copy of *Lotus Eating: A Summer Book* by George William Curtis, New York, 1852, with several loose drawings in it purporting to be Kensett's originals for his engravings illustrating the book, and would I be willing to look at them. Obviously I was delighted, so he sent them on and I wrote back immediately that there was absolutely no question of their authenticity and if he ever considered selling them, could I have first option?

He replied, "Of course, they'd mean more to you than to me. I'll be happy to sell them to you for a hundred dollars. I only paid fifteen."

Even though they were very small initial letters, end pieces and such, and Kensett wasn't in demand at that time, still that was so ridiculous a price for such exquisite little drawings that I told him I couldn't buy them at his figure and sent a somewhat larger amount. Athena Tacha carefully matted them, in the order in which they appear in the book, on one large sheet resulting in a handsome ensemble of exquisite small drawings.

One final Kensett incident is worth mentioning because it ended in such a nice bit of irony. In 1956 I happened into a junky kind of picture shop (you could hardly call it a gallery) on Third Avenue, where I spotted a small oil painting on board, definitely by Kensett and most probably a sketch from his last summer. Carefully not looking at it, in the time-honored practice, I asked the owner about this or that piece. As we chatted, a woman came in and demanded, "Are these pictures

John Frederick
Kensett, four of
twenty-eight tiny
drawings for
illustrations of
George W.
Curtis' *Lotus-
Eating: A
Summer Book*,
1852, graphite
on paper. Ex-
collection of Ellen
H. Johnson;
photos: John
Seyfried

originals?"

He replied, "No, there isn't anything in here but reproductions," so she left.

I said, "Why in the world did you tell her that? You don't have any reproductions."

"Oh, I can't waste my time on these people that come in off the street!"

Turning then to the Kensett, which bore his signature, I asked its price—fifty dollars, even then and for a very small painting and in that shop, an astonishing bargain. But not having liked his arrogant behavior to the woman, and knowing that the signature was spurious (Kensett didn't sign the little oil study sketches he painted at the motif, in those years anyway), I offered him forty dollars. He accepted gladly, flattering himself that he had made a good deal, passing off a little nothing as the work of a known artist, but I knew I'd got a Kensett.

Sometime before the Kensett investigations, I was concentrating on Cézanne, for class lectures of course (I've always been first and foremost a teacher); but also for a study I wanted to make of the museum's *Viaduct at L'Estaque* painting and the water color *Pine Tree at Bellevue*, partly with a view toward fixing a more solid date for each than I felt had been assigned. Throughout the 1950's and into the 1960's I was spending quite a bit of time on summer study trips in Europe trying to locate and photograph the exact source in nature of several Impressionist and Post-Impressionist paintings.

Erle Loran had published his book of photographs of Cézanne's motifs compared with the paintings; but I found it quite shocking the way he put great big arrows through paintings and sometimes cut off sections of pictures (perhaps because they didn't match up or, as he himself actually declared in one case, because that part was not important). Moreover, his photographs were in black and white, whereas I was working in color, that being crucial to the whole enterprise. How convey Mt. Ste. Victoire as Cézanne saw and painted it without that glorious red earth, silvery ocher mountain and deep blue Provençal sky? Moreover, as for the *Viaduct at L'Estaque*, neither Loran, nor Novotny, nor Rewald, nor anyone else to my knowledge had identified the precise motif for that painting.

Approaching L'Estaque from the north was like driving right through the back of Cézanne's painting, and when I saw it from out at sea, that part of the mountain he had painted was right there in every

Paul Cézanne, *The Viaduct at L'Estaque,* 1882, oil on canvas, 17½" × 21¼", Allen
Memorial Art Museum, Oberlin College, Oberlin, OH, R.T. Miller, Jr. Fund and Mrs. F.F.
Prentiss Fund, 1950; and below, the actual site of the viaduct at L'Estaque; photo: Ellen
Johnson, 1951

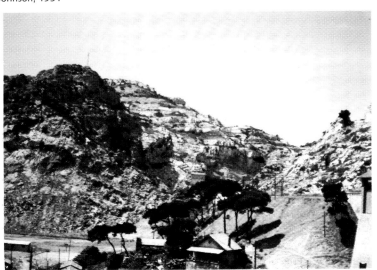

single contour. Even now, after forty years, I still tingle to remember—more than that—to experience once again the shock of joy at that first recognition.

In order to identify the specific objects in the painting, the building and the two viaducts in particular, a thorough investigation on the site was needed. And that was quite a harrowing experience. First off, climbing up and down the rocky hills, laden with cameras, tripod, books, and more gear, chased by wild dogs, and panting with thirst, I forgot caution and drank from a little stream (to my profound regret). Was that also the time I was stung by mosquitos and got a touch of malaria? No, that must have been in the Camargue when I was pursuing Van Gogh motifs.

My best Van Gogh find was the very spot from which he painted the olive trees near the hospital at St. Rémy, precisely identifiable by the angle of the little aperture in the background mountain which so resembles the "claws" of his much admired Hokusai waves ("the waves are claws. . .," letter to Theo # 533, Sept. 8, 1888). Altogether I found that that first modern expressionist intensified far more than he ever altered, and that that "madman's" forming mind was as crisp and clear as the ordered strokes in his carefully constructed art. At least when he was working, as he himself explained in 1888, "I work because I must, so as not to suffer too much mentally, so as to distract my mind."

Back to that grim day at L'Estaque. To find out everything I could about the site, I crawled up on the railroad tracks and walked out some distance on the viaduct, when suddenly around the bend came the train from the north. I'll never know how I managed to get back to solid land beneath the railroad ties and roll down the bank, cameras and all, just as the train rushed by.

Proposing a closer date for the Oberlin *Viaduct at L'Estaque* than Venturi's 1882-85 turned out to be quite easy once I thought of Renoir's *The Rocky Crags at L'Estaque* in the Boston Museum of Fine Arts and remembered that he had visited Cézanne in early 1882 and, as the two friends often did on such occasions, they went painting together. From L'Estaque Renoir wrote Durand Ruel in February 1882 that he was going painting with Cézanne. Renoir's painting in Boston is of the same motif as the Oberlin Cézanne. While Cézanne painted several pictures around L'Estaque, ours is the only known one of that view. Renoir's painting being signed and dated '82, Cézanne's can also

be dated with considerable assurance to the early months, and even quite probably February, of 1882 (see my "*Viaduct at L'Estaque*: A Footnote," *Allen Memorial Art Museum Bulletin*, XXI, 1963-64, 24-28).

The harder I strove to penetrate to the essence of Cézanne's thinking and feeling as revealed in his work, the more obsessed I became. One night in my sleep several little brush strokes, each a different color, came to see me and told me exactly, and at length, what it was like to function as Cézanne's *petites sensations* individually or in clusters, moving with or in opposition to each other, in the total complex structure of one of his paintings. When I worried that I'd never remember all those priceless details, one of the little planes of color said, "Never mind, I'll type it all up and put it in your mailbox at the art building." When morning came I rushed to the art building to get it, but the box was empty. Someone had taken it.

That's the only one of all my dreams that I recall now. I do remember a couple of visions, but no other dreams unless an experience I've had more than once when being given anesthetic might be called a dream. A great voice fills the sky with words that form a pun, in no earthly language, but one I then understand. Thus, the explanation, the end of the search, the whole meaning of the universe is only a joke. The voice roars with ear-splitting laughter until it fades away into the vast nothing.

It was while being immersed in Cézanne or some other artist that I had my worst professorial lapse. My customary practice when leaving the house in the morning, was to put the empty milk bottle on the stoop for the delivery man and the garbage into the sunken receptacle in the back yard. One morning, after performing these motions, I walked to class where I was just starting to return the students' blue books when I discovered it was not them, but the garbage bag I was holding in my hand; so I had to rush home, get down on my hands and knees and dig the papers out of the garbage. I had often arrived at the art building carrying the milk bottle, but garbage, that was the end! (Actually being engrossed thinking about an artist might not have been the only cause, it could also have been my habitual desperate struggle when grading papers. I never minded reading them, but trying to assign a just grade was torture. How could anyone determine whether an essay merited a C plus or a B minus? But it had to be done.)

Trying to track down Monet's motifs also afforded one or two

memorable moments, particularly when being held by my feet while leaning out a window in the Director's office at the Louvre in a final attempt to locate the particular place from which Monet painted Oberlin's *Jardins de l'Infante*. But, as is quite evident from the painting itself, neither it nor the version in The Hague was painted from any single spot of the Louvre, there being two points of view combined in the painting, straight across and straight down.

On another occasion, a perfect spring day in Paris, a friend proposed a drive out in the country to visit a friend of his that he was sure I'd like. Imagine my astonished heart when it turned out to be Monsieur Hoschedé, Monet's step son, at Giverny. (That was in 1951, some time before the place became a public trust.) The old gentleman was most amiable, seeming to enjoy greatly taking me through all the buildings, including the house with the room whose walls were still covered with Japanese prints, and the small studio and the large one in which, rolled up against the wall, were one after another of the great huge late paintings. After recounting how the Allies had been stationed on one side of the river Epte and the Germans on the other, firing back and forth at each other, M. Hoschedé pointed out bullet holes in many of the canvasses. He rolled out several of those grand paintings, till finally, struck quite senseless, I asked if there was any chance of Oberlin's purchasing one of them. He said one would have to ask Michel Monet. When I asked how one might reach him, he didn't try to disguise his feelings when he replied, "He's as always out in Africa or somewhere shooting animals!"

The waterlilies were not blossoming yet, but the wisteria branches hung from the bridge as they do so vibrantly in Oberlin's large late painting, and the flower gardens were glorious, even though M. Hoschedé lamented that there was now only one gardener where there had been six in Monet's time. Still I felt, as anyone must who stands in that place, totally enveloped in Monet's glowing paintings. Strange, the power a garden has to hold and evoke such a presence, somewhat the way a house can retain and reflect not only the behavior toward it of its former inhabitants, but their very character, how they lived their lives. (The power a scent has to carry one straight back into a past experience is not the same; that is just one's own existence, not someone else's.)

To continue my discussion, for now, of simply the external sources of an artist's creativity, my investigations in the 1940's and 1950's

were not limited to landscape in nature, but to other physical facts of importance in his or her environment. For the Cubists, with artists' increasingly narrowed place in the social scheme, the physical sources (the "starting-off" points to Picasso) were centered in the familiar objects of their studio and café life.

I decided in the early 1950's to try to identify the objects in Picasso's Le Verre d'Absinthe at Oberlin, a painting in which Roger Fry had declared "there is no recognizable object." By examining objects in all the published Picasso paintings and drawings from the Cubist years and in the few available photographs of his and other artists' and friends of artists' studios and residences, and by isolating sections in the Oberlin painting, I was able to identify several real things as they were presented in multiple, disparate and fractured views: the glass, spoon with sugar loaf, book, fan, table, and violin scroll. The resultant article, "On the Role of the Object in Analytic Cubism" (AMAM Bulletin, XIII, 1955-56, 11-25), is the most frequently cited of my writings, and it was the most fun to do—a soothing kind of a game, like a detective story.

When I first began thinking about the problem, two or three of the objects seemed easily identifiable, but other forms were quite puzzling, particularly a kind of spiral motif (finally identified as a violin scroll). I recalled seeing something like that in the decorated volute on a piece of furniture in some photograph of Gertrude Stein. Being in Paris then, spring 1951, and an ardent fan of Stein's (who had died not long before), I got the rather wild idea of consulting Alice B. Toklas. Not without shame at being so presumptuous, I wrote her a note. To my astonished delight she answered immediately with a cordial invitation to come for tea, an occasion that turned out to be not only very helpful but most entertaining. She seemed to find it deliciously amusing that Oberlin, which she obviously considered the last stronghold of conservatism, Puritanism and the Women's Christian Temperance Union, should have purchased Picasso's Cubist painting of a glass of absinthe. As the tea or whatever progressed (imagine not remembering what the author of the only cookbook I ever enjoyed reading served), she turned out to be such a forceful personality, not at all what I had expected, that I began to wonder if a good deal of The Autobiography of Alice B. Toklas wasn't exactly that. Miss Toklas invited me to come again, which I did a couple of times later, and she wrote me a few letters in the most elegant spidery hand I've ever seen.

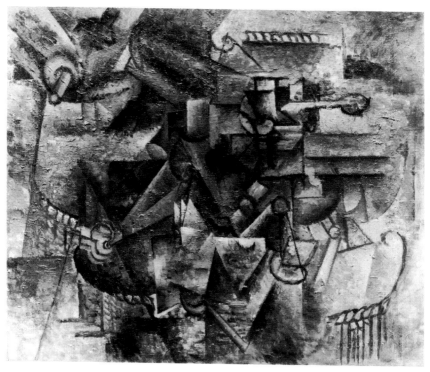

above: Pablo Picasso, *Le Verre d'Absinthe*, 1911, oil on canvas, 17¼″ × 21″, Allen Memorial Art Museum, Oberlin College, Oberlin, OH, Mrs. F.F. Prentiss Fund, 1947

left: drawing of Alice B. Toklas from Ellen Johnson's sketchbook, 1951

I may still have one or two, but, I've forgotten at whose request, I sent the best of them to the Stein/Toklas archives at Yale.

I recently came across the following notes I made after visiting Miss Toklas in the spring of 1951. I was amused by my unconscious imitation of Gertrude Stein's—or Alice B. Toklas' ?—style:

Alice B. Toklas is Gertrude Stein. Gertrude Stein was Alice B. Toklas. Alice B. is not a mouse; she is someone. Was she Gertrude Stein? Which is which?

Basket II is a white poodle, is very old. Has had two colds and the doctor says cannot have a third.

Stop coughing, Baskey, stop it. Don't be naughty, coughing like that, Basket. You are worrying me.

Picasso is tender. He loves pigs. He has no initiative. He can't say No. Therefore he says yes all the time. When Fernande left him, she brought Eve to him. She was little, pretty, dull bourgeois. Olga was beautiful. He loved her. Now she loves him. The son was Olga's. Dora Maar is a good painter, one of the few good ones today.

There is no royal road. You have to do it the hard way as we did.

Picasso's eyes. He drinks in things and they become his. When he came to see the portrait of Gertrude before it was sent to America, he talked and didn't look at it until just when he was leaving. Then he looked and looked for several minutes, then held up his hand. It was for the Metropolitan—very mad that it was loaned to the Museum of Modern Art for ten years.

Alice B. sold *Woman with a Fan* for money to publish the books. Mrs. Harriman bought it from a dealer.

Matisse showed him an African thing; he bought several. Gertrude gave him a couple.

He did not work from models. The Circus Medrano was not like that. Gertrude posed for him. Once he came in and said Braque had a model and he tried working from it, but it didn't work for him.

When he did Max Jacob's portrait he hadn't seen him for days. In the 20's he did several direct from the model. It is usually from memory—from himself.

Have lived at 5 rue Christine since 1938. Queen Christina is supposed to have stayed there, but that is a myth. She didn't stay in Paris. She followed the King directly to Fontainebleau.

Cézanne's *Estaque* in Oberlin—that's the nicest thing you've said.

Take all the photographs. [I took a lot of them.] Don't be so high and mighty—take them for yourself, not for the students.

You can't force art down anyone's throat. It is not to be popularized.

When they divided the pictures, Leo took the Cézanne apples. Much later Picasso brought Gertrude a little water color of an apple.

My having jotted down all these recollections of the search for visual motifs and object sources does not mean that I disregarded other external factors, events and ideologies that inevitably affected, impinged upon, and were reflected in the work of the artists studied. Nor did I neglect "the mysterious centers of thought." My writing and curatorial work on two Swedish artists deal almost exclusively with that realm of being. Both of them succumbed to madness, Carl Fredrik Hill in 1878 and Ernst Josephson in 1888, and thereafter produced drawings and paintings of remarkable power, purity and invention that prefigure works of Picasso, Matisse, Klee, Kokoschka and other later artists.

Hill and Josephson found reality in release from reality, whereas their contemporaries Cézanne and Monet found and created their concept of reality in a close and loving scrutiny of perceptual reality. Monet found it in the ever-changing, constantly moving immateriality of objects in the visual world, while Cézanne sought a more solid and lasting order, not by imposing it upon, but by discovering it within and drawing it out from the shifting, conflicting dynamics of nature. Yet, by different paths and different concerns, all four artists arrived at what Cézanne referred to as "the heart of what is before you."

FRAGMENTS
III

Whatever I remember from whatever time, it is always in a particular place where I find myself in a specific location and an exact position. I *physically* feel the space around me. It is not a conscious thing: I am simply there. Then the memory begins to take form. I wonder if other people remember like that, through their body's location in space. Perhaps everyone does. It's no doubt related to what is known as our "sixth sense, the proprioceptive," which lets us know where our bodies are in relation to our surroundings.

I can place myself at will wherever I have been by feeling myself in a particular city, for example, walking down the street, descending a subway stairs, hailing a cab, or boarding a bus (by far the most comfortable and pleasant in New York for a handicapped person). Or I feel myself walking along a dirt road on the crest of a hill in Mt. Pelion; on my left, mica-like green slate shines among low chestnut trees and enormous ferns whose moist fragrance is like a blessing from the prehistoric past. On the other side of the road several old shells of houses, with beautiful roofs of hand-cut and fitted pieces of slate, still stand as a silent reminder of what happened in so many remote Greek villages during and after World War II.

Or I put myself just below the surface of the water in the Caribbean, first gliding, then thrusting my body briskly forward to slither between two rocks out into the sea along the coral wall offshore of my favorite dive hotel in Cozumel. Or again I feel myself as a child skating over the ice on the river moving along with the fish visible through the frozen water.

In visualizing a painting or sculpture that I've seen, I feel myself standing before or moving around it in a specific room or gallery. A somewhat similar process occurs when I want to pull up a certain passage in a book or magazine. I can usually locate it easily because in my mind I see it right there in a certain position on the right or left side of a page.

Right now I recall a trivial incident from my High School graduation in 1929. I am sitting in the front row of bleachers on a stage. The front row position was due to my being valedictorian, although someone else wrote the speech. That seems to have been a customary practice in our school—most curious. In any case I'm glad I

Ellen Johnson (on father's lap) with her parents and her older sisters and brother, c. 1913; photo: Hornstrom

never wrote anything called "The Musical Scale of Life," which I had to memorize and deliver. When the audience and students were assembled and the ceremonies about to begin, I happened to glance down at my feet and discovered that I had on my dirty old sneakers. Well, standing in front of the audience and backed by three-hundred well-dressed classmates, that would have been a ghastly gaffe. In 1929, that is. Somehow I managed to get a message out to the wings and down to my family seated near the front, and before too long a pair of proper shoes were slipped up behind a lot of legs to finally appear at the back of mine, just before I got up to deliver the address with all the fervor that my elocution teacher could wish for. ("You must throw your voice from the diaphragm!" Hers was as solid as the Rock of Gibraltar; she would lie on the floor and pound it: "F-e-e-l-my-diaphragm. Step on it!" So we did, boys as well as girls.)

One of my very first clear memories is decidedly a body-sensory one, and I've also long considered it as my first aesthetic experience. The Allegheny River that ran alongside my father's hotel in Warren, Pennsylvania (now on the National Register as one of the early river hotels) is a constant presence in my childhood and youthful memories. Once when I was four or five I was standing on Aunt Hilma's porch across the street, and I felt the river in the air all around me: "the river, sweet-smelling, rotten, unforgettable, unforgotten" (Steven Vincent Benet's *John Brown's Body*). It must have just rained, because everything looked so sparkling fresh: the grass, Mamma's flowers, and the bushes and trees on the island and the hill that rose steeply beyond it. It was early evening and everything was still. I was washed—more likely scrubbed—in fresh clothes, and my long curls were carefully brushed and combed. (Those curls! A few times I was almost proud of them, as though I had anything to do with it. But always I hated to see that brush and comb come at me.) As I stood there looking out over the river to the hill rising straight up above it, I felt as clean and good as everything around me. For the first time I was conscious of my body in relation to and a part of a complete and rounded and quite wonderful whole. Of course I didn't know the word for it, but it was harmony I felt.

Another early, but more direct and simpler, aesthetic pleasure came from arranging and rearranging the beautifully colored and shaped firecrackers, Roman candles, skyrockets, pin-wheels and such, for days and days before the Fourth of July. I liked much better playing

with them in advance than when Pappa or my brother set them off on the Fourth. They were too noisy and scary and though brilliant in the night sky over the river, they were gone too soon.

I also remember once, when a somewhat older child, I awoke in the middle of the night. There was a terrible noise outside and everything was on fire: the sky, the river and an oil refinery not far away. I thought it was the end of the world (we heard a lot about that in Sunday School) and I decided the best place to be at such a time was in bed, so I crawled back under the covers—and went to sleep.

Ellen Johnson with her father in front of the Allegheny Hotel where she was born and raised, Warren, PA, 1939; photo: Marjorie Hoover

FRAGMENTS
IV

During the 1950's, besides my close involvement with Cézanne, Kensett, Monet, Picasso and the Swedes, I continued as always to see as much of the new art as I could manage on my weekend or holiday trips to New York during the academic year and to Europe in the summers. Of course I came upon the work of Rauschenberg and Johns, but I didn't get to know the artists until the early 1960's, and then Bob Rauschenberg only slightly, but Jasper Johns very well. Although they became called "the fathers of Pop Art" and were included in two of the first group shows of those artists later known as "Pop" (*Six Painters and the Object*, Guggenheim Museum, March 14—June 13, 1963; and *The Popular Image Exhibition*, Washington Gallery of Modern Art, April 18—June 2, 1963), neither Rauschenberg nor Johns had been in Sidney Janis' big ground-breaking *New Realists* show, October 31—December 1, 1962. Presumably Janis saw the difference between their work and that of those artists, American and European, in whom he perceived a common factor.

Janis' exhibition was far too large for his 15 East Fifty-seventh Street second floor gallery, so he rented a huge ground-floor space at 19 West Fifty-seventh, in whose vast window Claes Oldenburg's lingerie display startled the passersby, who could glimpse on the walls behind it Warhol's *Two Hundred Soup Cans*, Lichtenstein's *George Washington* and Rosenquist's *I Love You With My Ford*. It was a grand show, dominated by the Americans, beside whom the Europeans in general seemed far more modest in size and subject, and some a bit decorative as though with a touch too much make-up.

It was inevitable that some dealer or curator would have put together those artists who for the previous year or two had been taking their images direct from advertising and other areas of the media's visual over-kill in our commercial world. Unlike Futurism, Dada and Surrealism, there was nothing programmatic about Pop Art; the artists themselves formed no group. In fact few of them even knew each other until dealers and curators got them together. Neither Warhol nor Lichtenstein, for example, knew that the other had been making comic-inspired paintings at about the same time, Warhol in 1960, Lichtenstein in 1961 (although slightly earlier he had tucked a comic or two into an abstract painting). But Warhol didn't pursue that

field; and how vastly different his comic pictures were from Lichtenstein's elegantly, even classically designed compositions, executed in and exaggerating the alluring, slick style of advertising art and the Ben Day dots of comics' mechanical printing process, which so staggered the art world when first shown at the Castelli gallery in February 1962.

Regarding the Pop artists in general, I have always felt that, in spite of their common sources, their individuality far outstripped their similarity; and it was so that I dealt with them in my writing and lecturing, and it was so that I knew them as distinct human beings. As I recall, the only article in which I grouped them together, or dealt with them as a common phenomenon, was "The Image Duplicators: Lichtenstein, Rauschenberg, Warhol" (*Canadian Art*, XXIII, 1966, 12-19). Actually, I don't believe I ever spoke of Pop Art in what I wrote on those artists in the sixties, not because I found the social phenomenon uninteresting or unimportant. But I distrust easy labels that are clutched at and embraced to make it simple to recognize and pronounce, for example, "Oh, that's Pop Art!" and then promptly dismiss the work without really looking at it or thinking about it and its individuality. Even when I'm working on artists of the past, I like to learn as much as I can about them as human beings, to get as close to them as possible. So it stands to reason that I've gotten to know, and in many cases become friends with, the contemporary artists I've written about. It's partly because I find artists the easiest and most stimulating people to talk with and understand (try to understand).

In December 1961 Claes Oldenburg opened *The Store* (an earlier version of which he had exhibited that summer in Martha Jackson's *Environments, Situations, Spaces* show) in an actual street-front store at 107 East Second Street, in whose back rooms he concocted his painted plaster dresses, shirts, hats, shoes, carrots, cakes and ladies' panties, and exhibited them, hung with price tags ($198.95, $279.89, etc.) up front and in the window. Early in 1962 *The Store* became the *Ray Gun Theater* where he presented four happenings (he preferred the word "performances") on weekends for over two months. Performed without words to a small audience of thirty or so jammed together in darkness, and all but touching the actors, those pieces were extremely dramatic, mysterious, often violent, and totally absorbing.

I was so captivated by Claes Oldenburg's work that I wrote or called him and asked him if I might come to talk with him about it. As

Roy Lichtenstein, *Craig,* 1964, oil and magna, 35″ × 14″, Allen Memorial Art Museum, Oberlin College, Oberlin, OH, gift of Ellen H. Johnson in memory of Ruth C. Roush, 1979, © Roy Lichtenstein

Andy Warhol silkscreening at his fire house studio, New York;
photo: Ellen Johnson, 1963

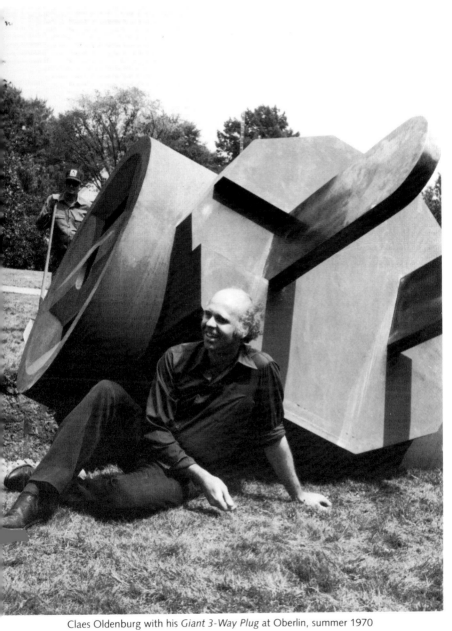

Claes Oldenburg with his *Giant 3-Way Plug* at Oberlin, summer 1970

soon as school was out in the early summer of 1962, I went to see him and found him extraordinarily generous, explaining his processes and problems, spending the whole day with me and even letting me borrow some notebooks to take back to the hotel, and inviting me to return to the studio where I spent a couple more days looking and talking. Long before I went to see him I knew that I would write an article about him (there had been reviews but no monographic study). I can't remember if it was on that occasion or, more probably, a slightly later one, that he gave me a lovely water color of a bouquet of flowers saying, "No hotel room should be without flowers." At the time I couldn't afford the hundred dollars that I assumed it would cost, so I returned it to him when I left town. Later he told me that he had meant it for me, but by then it had disappeared. Pity because it was such an expressively brushed, richly colored and glowing little painting.

While in the studio, of course I was taking slides as I always did, and still do. One of those evenings I spent trying to convince critic Harold Rosenberg that Oldenburg was an important artist, while he kept laughing and deriding me for wasting my time writing about such trivial things. We argued until three o'clock in the morning and while a lot of exciting ideas were exchanged, he stuck to his opinion. However, when we were together some years later at the opening of the big Oldenburg show at the Museum of Modern Art, he didn't hesitate to declare enthusiastically, "You were right. He's really good!"

While driving through Switzerland that summer of 1962, I called on James Fitzsimmons, the editor of *Art International*. I showed him slides of Oldenburg's work and said I planned to write an article on him. We had a good long talk, which he began by asking, "Why do you want to write about Oldenburg?" I wrote the piece at the little hill town of Loreto, and at the end of the summer I sent it to Fitzsimmons who said he wanted to hold it till the January issue, which he planned to devote to the burgeoning Pop movement.

Meanwhile back in New York in the late summer, I saw a good deal of Claes Oldenburg when he was working all over the floor of Dick Bellamy's Green Gallery, sewing (with Pat Oldenburg's help) and putting together and stuffing the giant soft hamburger, cake, calendar, and other things for his show there in September—October. In the following January (1963) I included Oldenburg in the *Three Young Americans* show, with Robert Rauschenberg and Joan Mitchell (catalogue and essay, "Is Beauty Dead?," *AMAM Bulletin*, XX, 1962-

63, 56-65). On January 17th Claes gave a gallery talk on his work, the first he had ever done, which made him a little nervous at the beginning, but he was soon sailing along into the rich, expansive, illuminating explication that characterizes all of his writing or talking about his work. In far too short a time he invited questions, and answered them with thoughtful honesty and captivating humor.

From then on I was much occupied with Oldenburg and was often together with him and Pat until they divorced, then with him and Hannah Wilke (but by the time he had joined forces with Coosje van Bruggen our meetings had gradually become rarer). One summer in the 1960's when he was away, Claes gave me the key to his block-long Fourteenth Street studio to come and go as I liked, look at, read, and photograph anything I wanted to in the entire place. It was an incredible experience to be so totally immersed in Oldenburg's work and thought. His notebooks are, and always will be, a gold mine. He once said he never let a day end without having made some entry, short or long, textual or visual.

Another time Claes sent all his notebooks (typewriter size paper snapped into sturdy loose-leaf binders—there were well over a hundred of them at that time) out to Oberlin for me to have at hand for several months. From that extraordinary richness of material, and the work I kept seeing at his studio and in exhibitions, and all the conversations with him, I wrote a book and two more articles. The piece on his metamorphoses that was published in *Art International*, April 1970, as "Oldenburg's Poetics: Analogues, Metamorphoses and Sources" was reprinted as "The Poetry of Everywhere" in my *Modern Art and the Object* (many of the essays referred to here were included in that selection of my writings, requested by Nikos Stangos then editor at Penguin's, subsequently at Thames & Hudson, and in my view all that anyone could ever hope for in an editor).

The "Metamorphoses" article was written as a lecture for Princeton, where professor Sam Hunter was so upset, when we were filling the projectors, by the great number of slides I had that he refused to put them all in, insisting "You'll never use all those slides. It's impossible; it will be awful; we'll stop loading here."

"Nonsense!" I said. "Calm down; I know what I'm doing."

The slides all got in and in order (there *were* an awful lot of them). After the introduction he sat down with a very pinched expression for the first few minutes; but he soon realized what I was doing and

relaxed, so I forgot him.

I gave that lecture all over this country and several places abroad. In 1971 Penguin's brought out my Oldenburg book, small in physical dimensions, but quite lengthy in actual amount of text—about the same length as Abrams publishers would have required, had I accepted their invitation, which came when Penguin's did. I chose the latter because I didn't want a big impressive-looking expensive publication, but rather a smallish light-weight paperback that could easily be carried, and bought by anyone who wanted it. It was in a series called "Penguin New Art," whose advisory editor, I've just noticed, was Richard Morphet, now a greatly admired and dear friend. Richard has done so much for contemporary art, from his first post at the Tate, where he is now Keeper of Twentieth Century Art.

In the fall of 1970 I wrote a piece on "Oldenburg's *Giant 3-Way Plug*" (*Arts Magazine*, XLV, 3, Dec.-Jan. 1970-71, reprinted in *AMAM Bulletin*, XXVIII, 1970-71 and in the *Object* book, 1976), which he had just finished installing that summer on the grounds of the Oberlin Art Museum, his first officially commissioned work for a specific site. Parenthetically, his famous *Ice-Bag* was first conceived as one of the proposals for Oberlin, but rejected as a visual obstruction to motorists at a major intersection and its soft material an invitation to vandals. Some years later, I had one of the loveliest surprises of my life when I opened Oldenburg's book, *Raw Notes*, (Halifax, 1973), and discovered that he had dedicated the publication to me.

Although my association with Oldenburg was closest and most prolonged, and I wrote most about him, I also knew, in varying degrees of friendship, the other major Pop artists, Andy Warhol particularly for a few years until he always went about with his entourage from the Factory, as his studio became called. I don't remember where or when (1962 or earlier) I first met him, possibly through Richard Bellamy. Although Bellamy didn't represent Warhol, I do remember that he had a couple of pieces of his. That backroom-office-storage space of Dick Bellamy's at the Green Gallery was a nerve center, a breeding ground, for much of the new art in the early 1960's. Oldenburg, Rosenquist, Judd, Morris, di Suvero, Samaras come to mind immediately along with Flavin and Segal, both of whom I had met before the Green Gallery days. I don't know how I got to know George Segal, but it was very early on that I went over to New Jersey to see him and his first plaster figures from life in the old chicken farm

building. (My article, "The Sculpture of George Segal," appeared in *Art International*, VIII, 2, March 1964, and in the *Object* book, there as "Cast From Life").

I do remember very clearly my first meeting with Dan Flavin. It was a day, most probably in the late 1950's, on one of my countless slide-taking visits at the Museum of Modern Art, when a young guard came up to me and said, "I'm an artist too." Could there be a better start to a friendship with an artist?

Wherever it was that I first met Andy Warhol, I knew him at the time of his first big exhibition of printed image paintings in New York, at Eleanor Ward's Stable Gallery, November 6-24, 1962. It was a dazzling show presenting at the outset of the "Andy Warhol" career the technique, visual structure, sources and iconography, with all the implied social meaning and desire, that would engage and cloak him for the remaining twenty-five years of his life: paintings with multiple *printed* images (at first hand-cut silkscreens, thereafter commercially produced photo-silkscreens) of movie stars (Marilyn) and other celebrities (Elvis), disasters (plane crash), commodities (Coca-Cola), all taken from newspaper and magazine photographs and ads, movies and television.

One day in March 1963 when I was visiting Warhol at his house on upper Lexington Avenue, I noticed as I was leaving several canvases stacked and rolled up in the coat closet. When I asked about them he shrugged and said, "Oh, those! They're just hand-painted pictures!" There were many 1960 pictures such as *BatMan*, *Delmonte Peach Halves*, *Superman*, and *Refrigerator*.

The first time I visited him he had the record player going. Since background music doesn't stay background with hearing aids, I asked him to turn it off. Incredulous, he opened his eyes wide and asked, in a sweet, boyishly petulant voice, "*All* the way off?!" (Strange, how so many people have now become so inured to incessant sound or noise that, in spite of how harmful it has been proven to body and psyche, they require it. More than "inured"—addicted, as to any other drug.)

It may also have been on that occasion that I discovered something else about my hearing. Andy was the first person I knew who wore dark glasses inside while talking with me. Right away that first time at his house I said, "Andy, take your glasses off. I can't hear you!" Eyes give me much more information about what's being said than reading lips would.

Andy Warhol at his fire house studio, New York; photo: Ellen Johnson, 1963

Of course that appealing insouciance I mentioned was part of the *Andy Warhol persona*, the work of art. But still I always felt, as long as I knew him, that beneath all the glitter and ironic sophistication was a fundamentally innocent person. This may be related to his voyeurism, his seen-from-afar, not participating, his untouchableness, revealing all and nothing. His gorgeous paintings are images of images, a world of surfaces. I think Alice Neel captured that paradoxical truth about Andy Warhol in her portrait of him: he exposes his wounded body, but keeps his eyes closed. His life is public, but he remains hidden.

Among the visual memories I have of Warhol are several from his studio at the firehouse on East Eighty-seventh Street in early 1963 and at 231 East Forty-seventh Street where he moved later that year. I took some lively slides of him fooling around with a spray can and down on his knees on the floor inking a silk screen, as well as of the aluminum foil and silver paint-covered walls (even those in the little open toilet) at the East Forty-seventh Street studio, which soon became known as The Factory.

Andy especially enjoyed chatting over the telephone. He often called me in the morning before I left for the day's round of galleries, museums and studios. (Apparently I was staying in New York quite a while that year, perhaps on sabbatical leave.) Once he asked, "Do you have someone that you always report to every day?" He didn't say it as though it were a chore, but rather a need to keep in touch. I wondered if he meant his mother rather than a lover; it sounded so permanent a connection.

Another morning he asked, "Are you coming to the opening tonight?" (Guggenheim Museum, *Six Painters and The Object*, March 14-June 13, 1963).

"No, I don't have an invitation."

"That doesn't matter. You *have* to come!"

"No, I simply don't go where I'm not invited."

When I returned to the hotel after 6:00 there was a message from Andy saying, "You are invited to the opening. See you there at 8:00." So I got dressed and took the Fifth Avenue bus up to the Guggenheim (in those days traffic went in both directions).

On the elevator going up to the show was Jasper Johns, who greeted me with a big smile, "Oh, there you are! I've been telling friends about the nicest person who came to my studio, stayed ten minutes and said, 'I won't bother you any longer' and left. I'm so glad

to see you again." After that we met often, either at his place or in elegant, quiet restaurants, often continuing the good talk over a night cap in some pleasant bar. On one occasion at least he came for me in a Jaguar sports car, I think it was—in any case it seemed a startling car for anyone as understated, almost sedate in bearing as he is, to own. Mostly we took taxies or walked leisurely. (Jasper was the first man I'd met who was so thoughtful as to enter a cab before a lady.)

One of the engaging things about Jasper Johns is the rather slow, hesitant, thinking way he speaks, carefully forming his inverted, involuted, subtle ideas. I tried to evoke something of the indirect, half-hidden and mysterious quality of his art and thought, when I was invited to write an essay for the catalogue of a Johns drawings show that the British Council presented in 1974. I said that instead of an essay I'd like to do something different, namely, to talk about Johns by quoting brief passages from texts that had nothing whatever to do with him (The Book of Ecclesiastes, Li Po, Heiddegger, T.S. Eliot, etc.). I thought such a back-handed approach would be most fitting and I loved collecting that "garland of thoughts," as I referred to it in the title of the ingenious little booklet that the British Council designed for it. Printed on the leaves of an accordion fold with Johns' *Ten Numbers* on the verso leaves and encased in a little plastic envelope, it was inserted in the catalogue (*Jasper Johns Drawings*, The Arts Council of Great Britain, September 1974), but not pocketed, so I daresay most of them have fallen out and disappeared long since. (Leo Castelli did have some of them available, but I don't know if there are any more.) Jasper liked it, and the most extraordinarily touching thing happened the last time I saw Tatyana Grosman, at I don't remember what opening or other occasion. She reached in her purse and drawing out the Garland booklet, she said, "See what I carry with me!"

Tatyana Grosman was very fond of Jasper Johns, and she told me many interesting things about him and his work when I visited her out at her studio. In the very early days she used to come to my room at the hotel carrying a large portfolio of prints for me to look at as possible purchases for the Rental Collection at Oberlin. Besides the incalculable contribution Tatyana made to American art, sparking the renaissance of print making in our country by encouraging and gently leading many of our finest painters to become great print makers— Jasper Johns her crowning glory—she was also one of the loveliest people I've been privileged to know.

Jasper Johns, *False Start II*, 1962, colored lithograph produced at the studio of Tatyana Grosman, Allen Memorial Art Museum, Oberlin College, Oberlin, OH, gift of Ellen H. Johnson in honor of Richard E. Spear, director 1972-1983, 1983

The only other thing I wrote about Johns was published in *Art and Literature*, VI, 1965, 128-40 ("Jim Dine and Jasper Johns: Art About Art"). As I hesitate to bother artists if I'm not writing about them, I saw far less of him after the Garland appeared; but we remained friendly and could pick up again when we did get together, as in January 1986 when I visited him overnight, in his handsome new house on St. Martin, on my way to Anguilla (one of the places where I go to snorkel in the winter). It was delightful to come out of the sparsely but perfectly appointed guest house in the morning to find Jasper Johns pruning the vines in his garden with the grave attention that he gives to anything he does: drawing, painting, reading, talking.

Those days he was at work on the *The Seasons*. As he continued showing me related works on paper (preparatory drawings or finished drawings of extraordinary power and beauty) he discussed the iconographical sources of individual images in his *Seasons*, primarily, as is now well-known, from Picasso. He picked up a paperback copy of Duncan's *Picasso's Picassos*, lying on a table in his studio, pointing out several details here and there that he had used from such paintings as, of course, the *Minotaur Moving His House* and the artist's shadow in *La Californie*, the image that haunts Johns' whole series. I was very

left, Jasper Johns photographed by Ellen Johnson and above, Ellen Johnson
photographed by Jasper Johns in his living-room, St. Martin island, January 1986

happy to have had that introductory look at the *Seasons* since I wasn't able to see the Castelli show; but I was lucky enough to see the great Johns exhibition that Mark Rosenthal assembled, and brilliantly explicated in the catalogue when it was shown in Philadelphia and New York.

To get back to the March 1963 opening of the *Six Painters and the Object* show at the Guggenheim Museum, from whose elevator I took off like Mary Poppins a couple of pages ago: when I finally stepped out of the elevator, I was horrified to see what a very private opening Andy had gotten me into. There were only the six artists (Dine, Johns, Lichtenstein, Rauschenberg, Rosenquist, Warhol) and a handful of Museum officials, dealers, and collectors who had loaned works to the show. I knew all of the artists and some of the others, of whom I recall only a couple. However I do remember most of the works in the show and I can still picture a good many of them hanging there.

Of course I returned and took slides, probably on a Monday when the museum was closed so I could use a tripod. I used to do that a great deal at the Museum of Modern Art and several other museums, even

the Louvre on a few Tuesdays. On one occasion at the Louvre Mme. Hours arranged for a ladder so I could take close-ups of Rubens' magnificent Marie dei Medici series. The sun was especially capricious that day. As soon as I'd get atop the ladder, with everything finally all set, it would either go under a cloud or move to another part of the gallery, so I'd climb down, go wake up the guard who was noisily sleeping off his noon wine and garlic, and begin all over again. (However, even with the rather poor camera I had at that time I did get a few sparkling details.) But I gave up the tripod years ago, not only because it became a nuisance lugging all the heavy trappings around, but I found that the tripod slides were really not all that much better. Holding the camera by hand allowed more flexibility in angle and choice of detail. It certainly saved time, which became increasingly important with the incredibly rapid growth in number of galleries. And artists. But whatever the equipment, my slides taken at the Guggenheim have never been really satisfactory because of the mixed light. (Over the years I've concluded that daylight film works slightly better than tungsten.)

After the opening of that second major Pop artist show (still not christened "Pop"), Leo Castelli invited me to a supper party at I forget which good restaurant. I sat between Jasper Johns and Andy Warhol and had a lovely time. Andy gave me the green plastic tie he was wearing for an early St. Patrick's Day, and at some time during the meal he and Jasper were talking about a bet, I think it was. Anyway, for some reason or other, Andy tore up a one or five dollar bill and Ethel Scull, who was sitting across the table, gasped, "But, Andy, it's money!"

While the *Six Painters and the Object* show was up, Claes Oldenburg said, not altogether jokingly, that I had kept him out of the show because I called him a sculptor in my article. Jim Dine, who had worked with Claes in shows at the Judson and Reuben galleries, also teased me; he complained that when I first went to see Claes I brought a bottle of vodka, but to him (Jim) I brought candy! Dine had taken me to his home the first time, rather than to his studio, and of course I had brought the chocolates for his two sons, of whom I took some sweet photographs with their father. He was and always has been a wonderful family man; anyone familiar with his work must realize the constancy of his devotion to Nancy. I became very fond of them both and kept in touch for many years, our contacts now far less frequent.

Dine was a visiting artist at Oberlin in 1965, not just for the customary day or two but for a long enough time to set up space for him, an office only, but adequate for any student conferences he wanted to arrange and a place where he could work undisturbed. Here he made quite a goodly number of handsome drawings and collages. When he returned to New York he developed a group of large paintings, the A.R. at Oberlin series, shown at Sidney Janis, November 1-26, 1966. On a particularly appealing blue painted canvas, objects, mostly of metal (a pair of bronze boots, two cast aluminum pumpkins, etc.), were attached and suspended, usually by means of a chain, down onto the floor below. They seemed joyous, spring-time paintings in spite of the aura of constriction or frustration conveyed by the heavy chains in some of them.

Soon after he returned to New York, Dine wrote:

> Dear Ellen, there seems little point in saying again how I feel about the last 10 days. In the light of things back here, I'm more convinced that it was one of the most meaningful things that ever happened to me. I've such different ideas about my work, myself et al. I can't say enough about how valuable your being at Oberlin is. I'm greatly moved by your dedication to all of "us" and your understanding and obsession with the New Art. Please write and let me know about Oberlin.
>
> love, Jim
> P.S. I hope you don't find the "double birthday" too daring to hang!!" [an adorable little lithograph, a diptych of a baby penis announcing the birth of his son Nicholas]

In connection with Dine's visit the museum had a show of his work, including the Black Bathroom No. 2, 1962, that grand painting with a sink that serves as a white shape throwing a black shadow on the white canvas ground, the total effect not unlike that of a black and white painting by Kline. I very much wanted the museum to buy it, but an ordinary bathroom sink robbed of its function and attached to a canvas didn't seem like an appropriate acquisition to the powers that were at that time. However, the museum did acquire in 1965, through

Jim Dine, *Charcoal Self-Portrait in a Cement Garden*, 1964, charcoal and oil on canvas with five cement objects, 125″ × 53″ × 31″, Allen Memorial Art Museum, Oberlin College, Oberlin, OH, Ruth C. Roush Fund for Contemporary Art, 1965

the Ruth C. Roush Fund for Contemporary Art, Dine's *Charcoal Self-Portrait in a Cement Garden*, 1964, a large and quietly impressive work.

Once during Jim Dine's residence in Oberlin, I asked if he'd be willing to talk to my seminar in contemporary art, perhaps showing some of the slides I'd taken over the years. Instead of choosing some, he simply loaded the projectors with all of them (they were arranged by date) and talked about each work: under what circumstances he made it, how he did it, why and what it meant to him. It was a thrilling experience for the students and myself; and Jim had a wonderful time; there were lots of things he hadn't seen for years and had completely lost track of. It's curious I never did that with any of the other artists whose work I've followed and photographed year after year, although various visiting artists have asked if I happen to have certain slides to fill in lacunae in the group they had brought for their talks.

When Brydon Smith was organizing the large retrospective exhibition of Don Judd's work for the National Gallery of Canada at Ottawa in 1975, a particular early piece that no longer existed was wanted for the show. The idea was to redo it, but there was no photograph of it. Don suggested that I might have taken a slide of it some time in his studio. Two of the four color reproductions in the excellent catalogue of the show are views I took of his studio in 1964. Brydon told me that when Don first saw the pictures he exclaimed that he had forgotten the small work with a plastic yellow H lying on its side. So all that endless tramping around streets, and up and down studio and subway stairs, toting a lot of heavy equipment, pays off in little unexpected ways besides the basic one of providing material for my teaching and writing, not to mention just pure pleasure looking at art and talking with artists.

I'm not sure when I first met Roy Lichtenstein, but I recall visiting him early on at his home over in New Jersey when he was teaching at Rutgers. When I asked to see his early work he took me up to the attic and showed me several canvases, including one of his first translations of earlier art, *Washington Crossing the Delaware* from 1951 (reproduced in my "The Lichtenstein Paradox," *Art & Artists*, II, Jan. 1968, 12-15), and other paintings in a Cubist-Matisse mode, and from the later 1950's Abstract Expressionist-inspired paintings culminating in a group of rhythmically moving wide bands of color that prefigure somewhat his brush stroke series.

Views of Roy Lichtenstein's studio, New York, with unfinished paintings and clipped comics on the wall; photos: Ellen Johnson, 1964

As is now well known, in the early abstract paintings he had introduced images from comics, which by 1961 grew into full scale pictures of such characters as Donald Duck, Mickey Mouse and incidents from romance comics that dominated his work for several years. Some of the latter type, including *Engagement Ring* and *Blam*, along with commercial advertising imagery (*Washing Machine*, *Refrigerator*) staggered the art public in his historic show at Castelli, February 10—March 3, 1962. At first, as in the ones in that show, Lichtenstein laboriously cut his own screens for the dot stenciling, but by 1963 he was using manufactured screens not only because of their ease and time-saving efficiency but also for the uniform, industrially produced style they provided, which completely befitted his intent. Though he used that style ironically and precariously, as he did his comic subject matter, he was as seduced by the machine look as ever Léger had been.

In 1963 Lichtenstein moved to New York, although he had had a studio in the city while he was living in New Jersey. His work space is always as clean and precisely ordered as his paintings. Among his beautifully organized files is a treasure trove of images that he cropped from various sources for his work, as I discovered when I fell in love with a painting, *Craig*, that he was working on in the spring of 1964. When I asked the price of it, he said he didn't know, "Leo takes care of all that, so I don't have to bother about it." It was among a line-up of paintings in progress based on comic romances (including *Seductive Girl* and *The Kiss*); priced at considerably less than one thousand dollars, I reserved it immediately. Of a modest size, *Craig* is especially appealing in its rather narrow vertical format.

In the original comic the girl exclaims "The Captain!," but Roy said he changed that to a shorter word in keeping with the design of the picture, and "Craig" seemed to fit the tone of comic romance books. Reaching in his files he pulled out the original comic and gave it to me. (I turned it over to Oberlin's curatorial files since I gave *Craig* to the museum in 1979 in memory of Ruth Coates Roush who made possible our acquisition of so many contemporary works.)

I have photographs that I took of Lichtenstein's studios and also of Jim Rosenquist's, which were as different from each other's as their paintings are. On Rosenquist's pin-up board, for example, clips and sketches were loosely attached, overlapping and flapping about. His whole studio had that kind of unsettled, on-the-wing look, heightened

at one time by the presence of his motorcycle, on which he often worked and polished right in the midst of his paintings. While his pictures are certainly ordered, they could hardly be more differently ordered; they are much looser, more open, with multiple, unexpectedly combined images overlapping and changing like images flashing by as one speeds down the highway. His whole studio bespoke the on-the-move character of his complex and richly varied art.

Several years ago the Archives of American Art asked for my papers, photographs and slides. I agreed, but said they couldn't have them until after I'm dead. (I certainly hope I don't have to go on living a long time if I should become so old, ill, weak-minded and self-centered that such things are no longer of use or interest to me.)

Back in that heady spring of 1962, a couple of months after Lichtenstein's Castelli show, Harold Rosenberg gave the Baldwin seminar at Oberlin (two weeks in May). I knew him well and we always got along fine together, although we argued much of the time. We were quite opposite in our approach to art and writing about it. He dealt in ideas, important, provocative ideas, whereas I began with the work of art and clung to it like a barnacle, whether it led me to any general idea or not. Also my writing is orderly and simple (except in these rambling recollections); Rosenberg's is daring and complex. He told me once that he would first write a piece in straight-forward and clear prose, then jumble it up a bit and make it more interesting.

During the Baldwin seminar Rosenberg went on lecturing for several sessions without slides while the students in my contemporary seminar got more and more restless. They particularly wanted him to talk about the contemporary work we had been studying; they were all fired up about Lichtenstein, Oldenburg, Rauschenberg, Johns. So I asked him to show some slides of the work of those and other young artists. "Slides? Anybody can talk about slides!" (That seems to be a widely held view.) "But if you insist, just load a carousel, and I'll talk about them." Which he did, interlarding his comments frequently by demanding, "Who's that, Ellen?"

Even on that relatively ineffectual occasion, Harold Rosenberg came up with some characteristically stimulating sweeping statements. His independence from the specifics of the work, together with his consulting of it, even if to a limited degree, are revealed in an instance Jasper Johns told me about. When Rosenberg was writing a piece on

him for *Vogue*, Jasper invited him to come to his studio to see the work. Rosenberg replied, "That isn't necessary; I've got some photos from the gallery." Black and white reproductions were all he needed to write his engaging article on Johns, "Things the Mind Already Knows," (*Vogue*, Feb. 1964). I have to keep looking and looking at the work itself and detailed slides of it, and talking with the artist whenever at all possible, in order to write or lecture about it.

While I have done some critical writing and have organized a few exhibitions, I have always thought of myself as a teacher (if not a preacher!). I taught a variety of subjects at Oberlin: Introduction to Art ("from mud to Klee" as Wolf Stechow dubbed historical surveys), Modern European Art (after the first few years called "Revolution and Tradition in Modern Art"), American Art (from Colonial to current), Scandinavian Art (primarily Swedish), Art Since 1945, a Museum Course, and a seminar (occasionally on a single early master such as Cézanne or Picasso, but mostly on Art Now). Obviously they weren't all taught the same semester; some of them alternated, but the two-semester Modern Art course was offered every year.

I enjoyed them all, but the Modern course was most exhilarating. It was also most burdensome because I didn't believe in limiting enrollment in introductory courses. Class size grew too large (reaching four hundred and fifty at one point) to allow any questions, so I offered optional discussion sessions and I was of course available after class and during liberal office hours. One way or another I got to know a surprising number of students, but to evaluate the work of the entire class was a fearful task. Mid-term and final exams were torture.

Obviously for two or three hundred or more tests to be graded, a good portion of the questions had to be of the short answer type. Easy enough with straight facts, it was far more difficult, but essential in my view, to devise questions to be answered in a few words that would assess not only the student's command of the material, but his or her independent thinking. For the finals there would be an in-class test of the more quickly read type of question, including some requiring a few sentences or a short paragraph. But there was also an outside, pre-assigned paper that counted for a least half of the grade and that was a good deal more fun to read, if harder to evaluate. The type of essays varied widely during the year and over the years, some requiring, some prohibiting, research, and all with several choices of topic.

The most revealing paper, and always a delight to read, was one I

often assigned as part of the final exam. I'd borrow from artists and dealers works that were totally unknown to the students, by artists whom we had not studied and about whom very little, if anything, was available in the literature, and the particular works themselves were so recent that no mention of them had been made in the press. In the spring of 1962, for example, students majoring in chemistry, history, psychology, economics, mathematics or whatever, for most of whom this was their first art course (in which no work had been studied beyond Dada and Surrealism) were required to write a seven or eight, maximum ten, page typewritten essay on Rauschenberg's *Black Market* of 1961. In early 1965 came Lichtenstein's *Craig* of 1964 and in 1968 a felt piece from 1967 by Bob Morris. There was always a choice of several works, the choices differing for those who had had art before.

The students had to apply what they had learned about analyzing a work of art visually and contextually, in terms of its significance in itself, and to other art, and in relation to the world in which it was made, to some baffling new kind of thing that I hadn't lectured on and they could not read about. Time and again a paper would begin, "When I first went into the museum to look at the assigned piece of art, I thought 'How can I possibly write seven or eight pages about *that*?' but now, after many return trips, I'm having a hard time cutting it to the ten page limit." Unable to fall back on anyone else's opinions, they came up with wonderful, fresh ideas expressed in their own, often vivid language.

I have kept and treasured a good many of those papers. Sometimes I'd take a set of them to New York to show the artists, who were always astonished at the variety of interpretations and insights. One time a businessman in Texas telephoned that he was applying for an advanced position and would like to include in his portfolio the final paper he had written in "Rev-Trad" (as the students called the course) fifteen years ago, if by any chance it was among those (about 50 to 75 out of thousands) I had saved. It was!

Occasionally among the new works to write about would be something I owned, like the Bob Morris felt piece I bought in the fall of 1967 when he had just begun working in that medium. Because it was such an easily transported large piece I included it in the United States exhibition, for which I was commissioner, at the First India Triennale of Contemporary Art in 1968. From New Delhi we took the American

Robert Morris, *Untitled*, 1967, felt, 12' × 6', in Ellen Johnson's Frank Lloyd Wright house, Estate of Ellen H. Johnson

collection to Bombay for a brief showing before its return to the States. After I included the Morris felt sculpture in the Modern Art final, I put it away because it was too large (eight strips, each nine inches wide and one-quarter of an inch thick by twelve feet long) for the intimate scale of the Frank Lloyd Wright house I bought that spring of 1968.

Some years later when Bob Morris was visiting and I was having a party for him, at about one in the morning he suddenly exclaimed, "Ellen! I know where we can hang that felt piece of yours. Give me a couple of big nails and a hammer." Draping the strips over two nails at the top, he spent close to an hour carefully adjusting this spineless work, which is supposed to take its own shape as it falls, into an extraordinarily beautiful random arrangement.

I forgot to put a note on it for the cleaning woman, "Art work. Do not touch!" She came next morning before I was up and when I came out I found the sculpture in eight neat little rolls. I fussed and fussed with it but was never able to get back anywhere near the way Bob had hung it, so finally I just laid the excessive fall in a straight line along the wall leading from the light, open, public part of the house into the darker, private bedroom hall, the "gallery" as Wright always designated it on the plans. That installation fits the dark, brooding, Egyptian quality that I find in several of Morris' black felt pieces.

The gallery in my house is a long narrow space, off one side of which open three bedrooms and the guest bath; the wall is composed of eleven-inch wide redwood boards, separated by small (two-and-a-quarter-inch) boards, which are recessed so as to cast shadows. All the horizontal boards and brick joints in the entire house, interior and exterior, are recessed to create lateral shadows emphasizing the horizontality so essential to Wright's concept of the house as growing up from the ground. That horizontal extension is echoed in the three book shelves that run the length of the hall (gallery) on the other side and are topped by a row of beautifully perforated boards (pierced windows). Turning the corner to enter the gallery one's eyes are drawn relentlessly down those speeding lines to whatever picture is hung over the desk in the little end room. I often hang my small black and white Kline painting there because it is strong enough to halt and stay the violent perspectival thrust toward the vanishing point, an illusion that is exaggerated by the picture's being framed in the open doorway, giving it the intense existence of something seen through a peephole, isolating the viewer with the viewed.

I will write about the house later, but now I want to go back to India (as anyone who's ever been there seems to want to do one way or another).

FRAGMENTS
V

In the summer of 1967 I was invited to serve as commissioner of the United States contribution to the First India Triennale of Contemporary World Art opening in New Delhi in January 1968. Under the auspices of the International Art Program, National Collection of Fine Arts, Smithsonian Institution, and the United States Information Agency, our exhibition was sponsored (read: largely paid for) by the Ben and Abby Grey Foundation of St. Paul, Minnesota.

I don't know what expenses were underwritten by the government; I assume some were, although our country, unlike other first world powers, has never seemed to realize fully the value of major national presence in exhibitions abroad. Private institutions and organizations, most notably the International Council of the Museum of Modern Art, have assembled and circulated many highly influential exhibitions. While in no way discouraging such activities, the government could and should increase its contribution. Hopefully the establishment in 1988 of the Federal Advisory Committee on International Exhibitions will improve the situation.

I was given free rein in selecting the American show for the Triennale, in securing loans, writing the catalogue, planning and overseeing the installation and handling much of the essential "representation," with the assistance of the curator travelling with the show. The two government officers that I worked with primarily were pleasant people indeed. Even so, I had enough contact with Washington and its seeming aversion to putting a clear statement or commitment in writing (telephone is not only more convenient but less binding?), and its tendency toward obfuscation (one never knows exactly what the situation is or where one stands in it) to vow never to get myself involved with the government again.

When I met Abby Grey in the Pan Am departure area to take off for New Delhi, all frustrations were left behind. She was a marvelous woman, a straight-forward, crisp, no-nonsense person in mind and speech, but open, warm and alive to everything, especially people, and most especially artists. She firmly believed in the concept of *One World Through Art*, her title for some of the exhibitions that she put together from her own collection and carried, at first literally, to numerous cities in Europe and the East. She also showed works from the collection of

foreign, especially Near Eastern, art that she had assembled, buying directly from artists, thus giving them immediate support and encouragement, during all the years of travel that she began soon after her husband's death in 1956.

En route to New Delhi we stopped briefly in Teheran where we picked up a friend and protégé of Mrs. Grey's, Parviz Tanavoli, an Iranian sculptor. I too became very fond of him. Not only was he a delightful and easy travel companion, but his response, both spoken and unspoken, to the wonders of Indian art heightened my own perception and understanding. On one occasion I was perhaps even more amused than enlightened. We went one night to a *son et lumière* in Delhi; it was a gorgeous and quite wildly dramatic spectacle. Whenever the Persians would appear on the scene perpetrating some evil deed, I could feel Parviz clenching himself to keep from shouting aloud his whispered, "But that's not true! It was just the opposite. They are falsifying history! It's terrible. It's a lie!" I wish I'd seen a *son et lumière* in Teheran.

Mrs. Grey had requested that we be put up at the charming old Ashoka Hotel that she was fond of, but we found ourselves stationed at a new shabbily constructed, ubiquitously modern, motel-like affair on the outskirts of town, having been told that we would like it better than the old Ashoka, which in any case was totally booked. Well, when thwarted, or determined for whatever other reason, sweet Abby Grey could be tenacious as a tick—yet so nicely so that obstacles just melted away. Thus we were soon chauffeured in to the Ashoka with its pretty but then rather neglected garden and its elegantly turbaned servants.

Next day to work, which began by meeting with officials, from whom we were dismayed to learn that apparently there had been a mix-up in Washington and nothing had been done about the catalogue, for which I had sent all the material long in advance. The Triennale was opening in a couple of days. Nonetheless, while I began checking the art works with our curator and planning the installation, Abby set to and got the catalogue printed in Delhi right away. No small accomplishment! It's a rather flimsy little thing, but it's all there and correct.

Before accepting the invitation to serve as U.S.A. commissioner, I had stipulated that time should be freed from official duties and arrangements made for me to visit four of the renowned monuments of India: the Taj Mahal, Khajuraho, Ajanta, and Ellora. (Of course I man-

aged to see other sites along the way.) The flurry of the opening was followed by television and radio interviews, discussions with artists and critics, lectures, and social gatherings of functionaries including the other commissioners. (The United States was awarded both sculpture prizes: Gold Medal, Joseph Cornell; Honorable Mention, Donald Judd.)

We had a peaceful interlude one day lunching with an old friend of mine, Jaya Appasamy, a well-known Indian artist who had been a graduate student at Oberlin. We sat on the roof garden of her rambling flat in Old Delhi and after lunch looked at several of her graceful, mostly figurative paintings, delicately brushed in large, simplified areas of nearly uniform tones calling to mind (mine, certainly not Jaya's) Milton Avery's handling of surface, shape and space. Mrs. Grey was delighted and immediately chose what to add to her collection. Parenthetically, as all her circulating exhibitions began coming home to roost in St. Paul, she considered various possibilities for placing her collection, and finally made arrangements with New York University that ended happily in the establishment of the Grey Art Gallery and Study Center on Washington Square.

After the opening and subsequent activities had quieted down, Abby, Parviz and I took off on our first trip, in a comfortable car under the care of a fine driver, a quiet man who carried himself with the aristocratic dignity that so many Indians seem born to.

I remember most vividly, first and always, the outstretched hands of the poor, thin bodies scarcely covered in dirt-colored rags that appeared at all the windows whenever the car stopped or even slowed down. They seemed to come from nowhere as though they just rose up from the earth. Villages in India look the same, with their buildings of dusty, earth-colored materials; those beautiful big dung patties dropped by cows often are used on dwellings, and even in the city sometimes as heating and cooking fuel. Cows, being sacred in India, are allowed to walk wherever they like, into the busiest traffic or, as happened one day when I was in New Delhi, out onto the tarmac of the airport, where somehow a couple of them got caught up into the workings of a plane taking off. After circling over the sea and dumping the fuel, the pilot miraculously managed to bring the plane down with damaged engines, undercarriage, wheels and wings, but no injury to the humans aboard. Another thing that particularly struck me while riding on the highways of India was the way road repairs were made:

men walked along slowly and patiently pouring tar through a sprink-
ling can into the holes and cracks.

Over all, aside from the painful poverty, what I remember most
and feel most deeply about India is its silence. There was no sound with
the begging hands along the road. The absolute stillness of that whole
deserted city, Fatehpur Sikri, founded in 1569 but abandoned in 1584,
chilled one's bones. At the same time I must admit it had an air of ex-
pectancy, as though it were a stage-set waiting for the actors to ap-
pear.

The Taj Mahal, where we went next, is a garden of silence within
the busy city of Agra. Even Khajuraho, despite its sculpture teeming
with activity, seemed quiet, still, alone in the empty fields. We arrived
in a small plane, landing in a field some distance away. It was just the
day after the Taj Mahal, an ideal way to see those two monuments,
one close upon the other. Both magnificent, they are complete opposi-
tes of each other: to go from the Taj Mahal to Khajuraho is to go from
the purity of geometry, the motionless perfection of death, of eternity,
to the throbbing energy of life itself in the wondrously contorted but
exquisitely graceful figures embracing and copulating— the whole
temple a celebration of the source of life, of change and renewal.

The majestic lingams, large, monumentally simplified stone sculp-
tures in the form of the male member, are dedicated to a similar con-
cept. In several of the temples at Ajanta, where we travelled after leav-
ing New Delhi, this phallic symbol of Shiva standing in the center of the
narrow dark space is so sited that it catches the rays of the sun, which
turns it into a golden image glowing in the darkness of the cave and
lighting up the paintings on the walls.

When we had arrived at Ajanta, it felt as though we were back in
the days of the Raj as Mrs. Grey under her parasol and I were each
borne up the steep and stony ascent to the caves in a palanquin—
actually not a "palanquin" since it was open, but that word so redolent
of a whole culture carries one, as we were physically carried, from the
immediate to the distant past.

Although the ground was level at Ellora, our next site, the transi-
tion was even more abrupt and the distance into a past world much
greater and deeper. To some extent that could have been because
there were other people at Ajanta, whereas at Ellora we were alone.
The silence was immense. We spoke in whispers, if we spoke at all, as
we moved up and down and through the temples and around those

awesome sculptures. The presence of age after age of worshippers at this shrine was so intense that one could all but see them dancing their slow hypnotic ritual before the sacred images. For the first time I thought it not impossible to understand a Christian missionary's need to combat the fearful power of those utterly alien gods. But my sympathy tends more toward the missionary who is *converted,* as in Sylvia Townsend Warner's "Mr. Fortune's Maggot."

Some years after our India travels I spend several more memorable hours with Parviz Tanavoli in New York, where he had come to talk with me about his work. I had been asked to write an essay for the catalogue of an exhibition of his sculpture to be sent to New York under the patronage and primary support of her Imperial Majesty the Shahbanou of Iran, "from the people of Iran to the people of the United States on the occasion of the American Bicentennial." Because I had found Tanavoli's observations about art so pungent and illuminating, I thought an interview with him would be most revealing; and so it turned out, as is apparent in my "Conversation with Parviz Tanavoli, New York, March 20, 1976," *Parviz Tanavoli, Fifteen Years of Bronze Sculpture,* Grey Art Gallery and Study Center, New York University, 1976. The morning after the opening festivities Parviz and his lovely wife Manijeh came to my hotel. He handed me a big old shopping bag from which I pulled out a magnificent lion rug, which I've now turned over to the Oberlin museum, it being the only example of its kind in a fine collection of Persian and other Near Eastern rugs.

My next encounter with Parviz Tanavoli was on the occasion of another grand gift from Iran. In the summer of 1977, just after I retired in June, I received an invitation to come to Iran in October as a guest for the opening of the Museum of Contemporary Art in Teheran. I went up from Australia where I was lecturing that fall, and was met at the airport by a very pleasant young girl, Niloofar Sh. Dowlatshahi, a granddaughter of the former Shah, or so I heard, who was the hostess assigned to me, with a car at my disposal, during the week of the visit. She checked me in at the posh Hotel Intercontinental, recently built in the universal hotel-modern style, like air terminals hardly distinguishable one from another. On the flight from Sydney, at any of the places where we deplaned—Manila, Hong Kong, Bangkok, Delhi, whose names conjure up such exotic images—we might as well have been in Seattle or Kansas City.

There was nothing out of the ordinary about the Teheran hotel

until I entered my room and encountered the extravagance of the fruit, flowers and provisions in the refrigerator. As soon as I tasted one of the grapes I thought, "Ah, Shiraz!," the wine that I had become so enamored of in Australia and wondered if the grape had a Persian connection. One bouquet was of so many perfectly matched, deep pink roses that I counted them; I got ninety-nine. That was just the faintest little hint of the opulent hospitality lavished upon all twenty-five or so of us guests, plus a few spouses, from Europe, United States, and Japan during our lengthy stay for the opening.

Before and after the event itself there was a stream of social engagements—luncheons, cocktails, dinners and late suppers, all at different homes, each host and hostess vying with the others for eminence. The food that lingers most delectably in my tasting memory, not surprisingly given my addiction, was the heavenly ice cream among the other delicacies on the evening buffets. The intricately designed serving bowls or baskets of spun caramelized sugar or honey were almost more delicious than the sweets they contained; as the hours lengthened I would go back and nibble bits of them with childish rapture.

One luncheon that I particularly recall was set in a lovely garden with many superb old rugs laid out on the grass for the guests to walk on and one or two of the tables placed on a bridge over a pretty pool. At table I found the wine so captivating that I asked the man beside me (there were always a few privileged Iranians among the guests) what it was. "It is a very special wine that is made only for our host; no one else has access to it."

From the gala opening, at which His Imperial Majesty the Shahanshah ("King of Kings," I think) arrived in full splendor mounted on his magnificent white horse, throughout all the festivities, it was like dreaming of the fabulous Persia of legend and waking up to find oneself still in it. But of course beneath the dazzle of ancient Persia was its equally legendary cruelty which, more than all the other traditional excesses, destroyed Shah Mohammed Reza Pahlavi's regime.

In the West during those years we heard and read much about the senseless injustice and brutality perpetrated at his behest, but almost nothing about his contributions; and those contributions were not limited to technological advances adapted from the West in his doomed attempt to bring Iran into the modern world overnight. In the development of more than the material well-being of the people the

Empress Farah Pahlavi played a major role: in education; improving the lot of women; bringing internationally regarded figures in the arts and other intellectual areas for lectures and conferences; implementing and supporting exhibitions of major art from other lands; and helping people more directly, as in her work for the blind, for example—to mention only a few of the Shahbanou's activities that I happen to know about. From that perspective she was a good deal more than a beautiful figurehead.

Obviously she was behind the establishing of the Teheran Museum of Contemporary Art, whose opening was held in the Imperial presence. As the procession passed our group we were each presented to the Shah by Kamran Diba, the museum's director and architect, who had studied in the United States. After going through all the galleries and watching some of the performances, Their Imperial Majesties departed. However, the Empress Farah Pahlavi returned and sat in the glass-walled restaurant, where we were looking out at the spectacles and dances performed by Iranians and foreigners on the multiple-roof terraces. As a matter of fact the whole opening of the Museum of Contemporary Art was part of the week-long national celebration in honor of the Shahbanou's thirty-ninth birthday. Following the display, we were taken to another part of the building and given private audiences with the Empress. I was greatly impressed with her friendly manner and informed and interesting conversation. She was herself a student of architecture, in Paris I believe, when the Shah chose her to be the Shahbanou.

The numerous opening activities lasted several days, both indoors and on the museum's multiple terraces and grounds. The building itself is a meld of traditional Iranian and modern Western design which, despite eight or nine roof levels and even more light scoops, still grows from the ground as an organic whole, like a cluster of bushes. There were nine exhibitions, each with a separate catalogue, of twentieth century Western and Iranian art from the museum's collection supplemented by loans from the Empress. All this is discussed in my article, "Tehran: The New Museum of Contemporary Art," *Art International*, XXII, April-May, 1978, 11-17.

Before and after the opening I had quite a bit of time for seeing the museum. Mornings were usually free except for an all-day trip to Isfahan where we were the guests of the Governor and Mayor. I also went on a shopping expedition in the bazaar with Manijeh Tanavoli,

and with Parviz to his carpet man, where Waldo Rasmussen came along for a while. He resisted the temptation to buy anything but fortunately I succumbed and bought a lovely double bag from Lori, which I've now given to the Oberlin Museum. I also greatly admired another bag rug, from the Salouchi tribe, but it was beyond my means. Because of Parviz' thorough knowledge of Persian rugs, it was a most enjoyable couple of hours. He himself has (or had, heaven knows what he has now) a fine collection, one group of which, the lion rugs, was exhibited at the Textile Museum in Washington (I believe).

As we were leaving the dealer handed me two parcels and I said, "But I bought only one."

"Oh no, they are both for you." I should have remembered the traditional Eastern gesture; because I had admired the Balouchi rug, Parviz would naturally give it to me.

Besides studying and photographing works in the museum, I also had some good talks with David Galloway, the Chief Curator, who was extremely busy as he seemed to have a lion's share of responsibility for the logistics of the whole complex event. I tried to get a flight to Persepolis but all were booked because of a festival of the Empress there. It seemed cruel to be so close and not be able to see it. At the museum there was a one-day panel and in-house seminar, but no elaborate program of lengthy lectures, no speeches at all the whole week, only a few charming toasts of welcome or thanks, the latter by some of our group, including Tom Messer, Pierre Restany, Wolfgang Becker, and Governor Rockefeller, who together with Mrs. Rockefeller were guests of honor at a brunch on the museum's dining terrace.

After the initial sight-seeing in the city, I rarely called upon my nice hostess, as we were taken to the social events and the museum was only a short walk, along Park Farah, from the hotel. Toward the end of the week I had to go to a bank in the center to exchange the reimbursement for travel expenses and that drive, like every other drive in the city traffic, was a nightmare. Two or three lanes on each side of a boulevard were a solid mass; someone on the extreme right would suddenly decide that he needed to be on the extreme left so he'd just swing over bang in front of all the oncoming cars. Strangely, everyone was very obliging—no screams or curses or blaring horns. But is was a mess and took forever. A caravan on camels could have moved at least as fast.

For me, the Teheran traffic symbolized the far-reaching, over-all

Persian, *Lion Rug (Quashqai Rug)*, c. 1910, wool, 44″ × 52″, Allen Memorial Art Museum, Oberlin College, Oberlin, OH, gift of Ellen H. Johnson, 1987

problem of an ancient land adhering to centuries' old traditions being thrust over-night into the middle of the twentieth century and a totally alien culture. Like a blood transfusion of the wrong type, the body rejects it—often tragically. My 1978 article ended with a wish "for the Teheran Museum of Contemporary Art, as for the trees in its garden, a slow, steady and healthy growth."

When I left Iran to return to Australia, in the refrigerator of the plane was a huge package (a pound or more) of the finest caviar from the hostess of the elegant garden luncheon, Monir Farmanfarmaian. I had enjoyed talking with her about contemporary, particularly Iranian art, of which she had a fine collection. Monir was a well-known artist herself, having a show the next month at the Denise René Gallery in New York.

The return trip turned out to be a real Odyssey that began at 2:30 in the morning of October 17th when I went to the dingy little airport to catch the plane I was booked on for Singapore. Not only was there no plane, there wasn't even a Singapore Air representative. After two or three hours of asking anyone I could find, I finally learned that the flight was at least ten hours late. After another lengthy struggle, I managed to get a cab and went back to the hotel for a brief rest.

At 8:00 p.m. the plane finally took off for Singapore. We were supposed to come down at Colombo, capital of Ceylon (Sri Lanka), but we ran into the tail end of a monsoon and there was no way to land, so we battled along for ages until, forced down for lack of fuel, we managed to land at Madras, where we sat or stood outside in the steamy heat for five or six hours and watched, half drowned, as the trucks supplied fuel to the scheduled flights before we could be served. When we got back on the plane the refrigerator had long since lost its cool and the food was almost gone. Back we went to Colombo and finally on to Singapore, where miraculously I made a good connection on a Qantas flight to Sydney, arriving there after forty-eight hours en route.

Utterly exhausted, with no sleep for sixty-nine hours (and a package of even more exhausted caviar), I got to my suite at Wellesley College and began to gather together my notes and slides for the Power lecture that evening, my first public appearance in Sydney. The person making the introduction (probably Tony Bennett, art department chairman) mentioned my long and strenuous journey, so I began by saying, "This may be the first time I go to sleep in my own lecture." But, as it was neatly typed, I managed to get through it and to stay

awake through the reception that followed.

Besides doing the Power lecture, I had agreed to serve as a Visiting Professor in the art department at the University of Sydney for the spring (our fall) term. That entailed considerable consulting as well as giving one lecture a week for four weeks on contemporary art in Ian Burns' class, an occasional lecture in other areas such as museology, and a couple more public lectures—a very light assignment compared to the load I was used to at Oberlin. Still I kept very busy, what with studying and photographing in museums and private collections (where I was particularly struck by my first encounter with Aboriginal art), talking with colleagues (a couple of whom took me on some interesting excursions out of Sydney), and all the entertaining that came my way, including many lovely dinner parties with stimulating people. It was all so pleasing I scarcely minded the sticky flies that covered one's back while walking through the campus and even on the city streets. Each day I passed a great jacaranda tree aglow with voluptuous purple blossoms, the first I ever saw. Of course by the time I left Australia I'd seen all sorts of strange and wonderful plants and animals.

I very much liked my colleagues and all the other people I met. They couldn't have been more friendly and helpful. And I made some special, and lasting friends: Susan Moore and Miguel and Conchy Bretos. The latter with their three children were always taking me on some or other happy outing, and I spent many pleasant hours at the home of Susan and Elvin and little Stephen Moore, but I particularly enjoyed looking at art with Susan and talking seriously about all sorts of interesting things.

The Power Lecture in Contemporary Art was an annual event established by Dr. Power for bringing critics from abroad to give Australians first-hand reports on the international art scene. The lecture was presented first in Sydney, the locale of the Power Institute of Fine Arts, and then taken to each capital and a few provincial cities. It was a gala occasion at every venue, but in Sydney especially so. The Power Lecture was first given in 1968 by Clement Greenberg; other lecturers included Lucy Lippard, Alan Bowness and I don't remember who all. Apparently my lecture went all right, judging from the lively discussion and compliments at the reception afterwards. It *was* a good lecture, "Originality: A Mixed Blessing in Modern Art."

I also enjoyed looking at some very elegantly dressed people, especially Miguel and Concy Bretos, he in a dazzling white dinner jacket

and she in a snaky gold something. It was amusing to watch two or three art dealers buzzing around them because they were so striking and prosperous looking.

The next day I had to begin the daunting task of giving the same lecture all around and across a whole continent. Each morning of the first four days I'd have to take off to another city, be met by a nice person from the Arts Council, and/or the university or other hosting institution, accompanied in the larger places by TV, radio or newspaper reporters wanting an interview. I would be rushed to the hotel, sometimes with barely time to throw water on my face and slip on a long dress before dashing off to cocktails at someone's house, dinner elsewhere, then the lecture, followed by a reception (always with a good, intelligent discussion)—and off early the next morning on another trip. At Melbourne, Adelaide and Perth I had short breaks of a day or two allowing time to talk with colleagues and visit schools and museums and be driven around the country a bit—including a visit to Barossa Valley vineyards, a most welcome treat. From Adelaide I flew half-way at least across the country to Perth, a lovely city, open, clear and fresh; it seemed to glow quietly like a pearl.

During the lecture at Perth, I poured water into a glass and spilled some on my hearing-aid (which I always take off when lecturing, as my own voice so magnified is highly distracting). Of course that ruined it. I left early the next morning for Darwin where I was to have two whole days and half. Upon arriving there, I asked immediately to be taken to an audiologist, but there was only a jeweler who sold hearing-aids. He said he didn't think it could be repaired, certainly not by him, but perhaps at Sydney—and he would lend me one to use meantime.

"But," I said, "I won't be returning to Sydney for two weeks."

Still he insisted that would be perfectly all right. Imagine handing over a new five-hundred dollar hearing-aid to someone he'd never seen before and never would again! The Australians are marvelous people. At least all the ones I met are as open and generous as their wide-spreading land.

That was particularly true of the art faculty, all very young, at the equally young Community College in Darwin. I never met a group of people that I had so much fun with, as well as stimulating talk, immediately and all through a several day visit. All five or six of them with some wives or sweethearts came to my hotel for dinner in a private dining room, where they kept bringing one after another Australian

wine they were proud of until we were asked to move to the cocktail bar. There we went on till that closed too. Sometime before the evening got too hilarious I asked about the possibility of getting into Arnhem Land. They said it's very difficult, virtually impossible, as the Aboriginals admit only very, very few other people.

"But don't you want to go see the great cave paintings?"

"Oh, of course!"

Feeling quite expansive at that point I asked if couldn't we charter a plane. Then one of the boys remembered a friend who was a pilot and another knew someone who had a small plane, so the chairman said he would send a telegram to the chairman of the Aboriginal Council in Arnhem Land requesting permission to enter the day after tomorrow.

The next day a couple of the boys drove me out a bit into the outback to see the fascinating magnetic ant hills, huge vertical sculptures rising straight up from the ground. Several of the few cars we met on the way had attachments in front, which I was horrified to learn were kangaroo catchers. It seems that those lovable animals have become so over-populated (like our deer) as to be a hazard on the highway, often causing serious accidents. It was great to be right out in the country instead of just riding over it in a plane. Fortunately, the flight from Perth to Darwin, which had stopped at two or three places, including Kimberley, and taken about as long as from New York to Phoenix, was in a smallish plane flying low so there were spectacular views of desert, scrub land, sea edge and rock formations. I took many color slides, especially of forms in that intense, burning, brick red earth or sand, which, when seen close-to, is in countless tints and shades of red.

It was very hot and sticky in Darwin, one-hundred-plus degrees, and though it is right on the Timor Sea, I couldn't swim there because of sea wasps. These wasps are very large, fatally poisonous jelly fish, which do go away in the winter months (May to August), probably the best time to visit the Northern Territory.

In the three days that I was there I was also entertained and taken about by the Arts Council people. I went to the museum where I saw many Aboriginal works in storage and to the Aboriginal Arts and Crafts Center, under Mrs. Bennett's direction, where I purchased several pieces of Aboriginal art from Arnhem Land: four bark paintings from Oenpelli in Western Arnhem, and one from Central Arnhem along with a wood sculpture of a Mimi—tall thin spirits that live in the rocks. I

gave the Central Arnhem bark painting to Susan Moore and brought the Oenpelli ones to Oberlin. The best of them (*Three Mimis* that makes me think of a Klee) I reserved for the museum, another for the Rental. I gave Chloe Young one, and kept one for myself of a lizard in the "X-Ray" style.

In the morning of the second day, November 23, I set off in a small plane with four of the faculty (they had drawn lots) and the pilot, even though no permission had yet come to enter Arnhem Land. The permission arrived, by radio from Darwin where it had come by telegraph from the Aboriginal Council, just as we approached the border. Two of the boys took off by foot for the Oenpelli station and eventually came back in a jeep driven by a stunning, brilliant deep black Aboriginal who came right up to me and said, "Telegram come day before; you big lady" (like "big feller" in Upfield's novels), so I knew it was me who would have to speak to the Chairman of the Aboriginal Council.

The Chairman, Joseph Bumarda, was an impressive person who received us with grave dignity and arranged for us to be driven to the painted caves that we had requested to see. The driver-guide led us as we climbed and crawled up the rocks to the caves whose walls and low ceilings were filled with sacred paintings, layers of sometimes overlapping images as at Lascaux. As we approached the area, with one accord we fell silent, the feeling was so strong that we were walking in a consecrated place, where we really should not be. We stayed for well over an hour, speaking no more than a faint whisper. The guide occasionally, in a very soft voice, identified some of the figures as I took slides.

On our way out of Arnhem Land, stopping again briefly at the station with its few scattered buildings including a super market, it was shattering to see traces of our civilization—Coke and other tin cans, piles of them left lying where they had been tossed all over the place.

That night was my lecture, actually two lectures. I had enjoyed the art faculty so much that I told them I wished I didn't have to give the Power lecture that was getting to be such a chore to repeat. They said they would love to hear me on Oldenburg; the Power being obligatory would I consider giving both? For them, of course. We got my slides flown up from Sydney. The Power was first, then a reception, followed by *Oldenburg's Metamorphoses*, the old war horse that had taken me all over the States and a few places abroad. It was a big audience,

Nabardayal, Australian, Western Arnhem Land, Gunwinggu, 20th Century, *Mimi Spirits*, earth colors on bark, 19½" × 16", Allen Memorial Art Museum, Oberlin College, Oberlin, OH, Charles F. Olney Fund, 1978

between two and three hundred people and everyone stayed for both.

The next day all the art faculty and a couple of people from the Arts Council came to see me off. The boys said before I came they had got word that I was sixty-six years old and had been ill so they were expecting some little old lady doddering along on a cane. As it turned out, they told me, after I left they were going to need a rest. I had worn them out!

One of my stipulations in accepting the invitation to give the Power Lecture had been that I be allowed a few days off to visit Ayers Rock and a week for the Great Barrier Reef. As one flies in a small plane from Alice Springs to the Rock, the mountains are like big sleeping lizards or dinosaurs and the clay earth-sand, as everywhere in the outback, is bright Gaugin salmon pink or red, too good to be true. But that is nothing compared with the symphony of reds touched with gold playing over the rock at sunset, which the Chalet people took us to see. That was the only inn there in 1977; in fact I didn't even see any other buildings.

At sunrise I went along with two men who were climbing the rock and I walked around photographing various shallow caves and other formations, all of which are thoroughly identified in the wealth of material on the mythology of Ayers Rock. Some of the sacred places are still forbidden to non-Aboriginals. The rock is also famed for its size, as large as the whole of London and its suburbs, and usually called a monolith, although that may not be geologically accurate.

The next day at Alice Springs, before leaving for Sydney, I went to the Aboriginal Arts and Crafts Center (there's one in each city or town). Originally there were no bark paintings in Central Australia because there were so few trees; they "painted" on sand. Now they have learned to use commercial colors, and they have become commercially successful at home and abroad. The paintings, which Aborigines call "Dreamings," are all abstract in this area. Dots and circles represent watering holes, vital in a desert land.

Back in Sydney the following day I took care of accumulated work-mail and other chores, ran errands, and got together my snorkeling gear for the upcoming holiday. Several invitations had come to lecture here and there, including a whole tour in New Zealand, but I had to regret them all because of my previously and carefully scheduled travel arrangements. Tony Bradley took me to dinner that night in his very elegant club, everyone in high dress, the men with all

their medals and decorations. I fully expected Peter Wimsey to saunter in any minute.

En route to snorkel-land I spent a couple of days in Brisbane, my last lecture stop. I found it a city rich in art: the Queensland Art gallery; an anthropology museum and an art gallery at the university; a new art center about to be built; a civic gallery; and an up-to-date Institute of Modern Art—among the particularly lively institutions. I had dinner with an elderly Viennese art historian, widow of a distinguished architect (who had constructed a splendid rain forest, no doubt an immense kind of conservatory, attached to the house so that sitting inside and looking out one seemed to be right in the midst of those great trees and other tropical growths). Like all other Viennese whom I've known she was an absorbing—and exhausting—conversationalist. The next evening I had dinner with the Lady Mayoress who introduced me at my last (thank goodness!) Power Lecture. It was a great audience—standing room only—of intelligent and contemporary art-informed listeners, so it was a good send off.

Early the next day I flew to Gladstone and picked up the helicopter for Heron Island. The coral reef, visible from the air in the clear water, was extraordinarily beautiful—purple, green, pink, red, blue, like a vast waterlily pond by Monet. Snorkeling on dive boats, or right off my lodge on the coral island was magic, with several exotic animal and plant formations unlike those in the Caribbean reefs. Most astonishing to me were bright blue star fish.

The last day in Sydney went to tying up work at the University and Power Institute, visiting friends, hosting a thank you dinner at a nice restaurant, and packing. The Bretos family came December 10 to take me to the airport. Miguel assembled all my baggage into his car somehow: two suitcases; a large burlap-wrapped roll of two Persian small rugs and other mementos of Iran; a duffle-bag filled with snorkel equipment, two kangaroo skins, and other antipodean treasures; a case of Shiraz-Cabernet; a flight bag stuffed with camera, lectures, slides and notes, two or three special books and other irreplaceables; a large purse and two immense banksia flowers (dried they are still beautiful in a brass jug from Aurangabad on a shelf in Oberlin). Susan Moore was also at the airport to see me off at 9:00 p.m. for Honolulu where I arrived at 9:30 a.m. the same day. I stayed at my favorite hotel, the Kaimana (where an orchid is always on one's plate at dinner and even breakfast) at the foot of Diamond Hill, a good tree-lined walk

away from the Waikiki resort area, but close enough to enjoy its pretty lights in the velvety dark, sweet-smelling evenings. I stayed over for a week of quiet ease, swimming in front of the hotel or snorkeling at Hanauma Bay with Mary Jane McQuillan, an old Oberlin friend, reading, and trying to put some order in my thoughts about the past three months on the other side of the world.

At San Francisco, Stanford professor and sculpture historian Al Elsen met me at the airport with Hunk Anderson, Oberlin alumnus who became such a great collector of modern art. They took me to see Hunk's fabulous collection from Maillol to Pollock to Lichtenstein, Johns, and beyond, quantities of splendid works (pity the Oberlin art connection doesn't seem to have been maintained). We went first to his offices and then to his art-filled home for dinner and the evening with the family. I left on the red-eye flight for home in plenty of time for Christmas, 1977.

FRAGMENTS
VI

Sweet, big, bumbling Ed Capps couldn't bear to sacrifice a single one of his huge collection of beautiful slides of ancient art just for the sake of coherence. "We turn now to one of the most majestic figures in the whole history of art, the *Poseidon of Artemesion.* Have you ever seen a more noble portrayal of the nude male body? On the left screen is a detail of his superb head. Oh, sorry, that's another view of the *Aphrodite of Cnidos*—her left, ah, er, upper torso." Time and again he was talking about a work that was ludicrously different from the one on the screen. But among the snickering students there were always a few who recognized and responded to the poetry and love that showed through his shambling lectures. He was such a good-natured man that he didn't stir up a fuss when his written proposal for a sabbatical leave was rejected on the grounds that his description of the Pilgrimage Road that he intended to study sounded too much like a pleasure trip. And so it would have been for him. He loved to look at art, even more than at baseball, pretty girls, and his and his wife Polly's beloved wire-haired terrier; and he gazed with equal innocence at all of them.

At a department meeting one day when we were looking through applications for admission to the M.A. program in art history, he took one look at Athena Tacha's photograph (included on applications in pre-affirmative action days) and exclaimed, "Grab her!" Not that Professor Capps' enthusiastic backing of a brilliant Greek student was really needed considering her qualifications, but he was instrumental in securing financial support for her in the form of a graduate assistantship. It soon became clear that this young foreigner was not only a superb student, expressing her independent ideas with startling exactitude in the English language, but also a quick-witted, thorough and efficient worker and a delightful person to have around. Athena Tacha was the only art graduate assistant who ever completed the requirements for an M.A. at Oberlin, including examinations and a substantial thesis, in one year, while working part time in the slide room and as a summer assistant to Forbes Whiteside and me in the Summer Seminar for Public School Art Teachers, a strenuous six-week program.

At the end of the summer, having passed the three-day written

Ellen Johnson, Professor of Art, lecturing in the Allen Art Museum of Oberlin College at the peak of her thirty-year teaching career, 1964; photo: Arthur Princehorn

Athena Tacha, *Green Acres*, 1986, brick, green slate, plants and photosandblasting, 5′ × 80′ × 90′, Department of Environmental Protection, Trenton, New Jersey; photo: Richard Spear

and one day oral examination and defense of her thesis, all of which the Oberlin Art History Department then required, along with two foreign language exams, for completion of the M.A. degree, Athena Tacha went to Paris where she earned the Ph.D. in Aesthetics at the Sorbonne in two years! As a student in Oberlin's Museum Course Athena had made such an impression on the museum staff that she was offered a job as assistant curator when she decided to leave Paris and return to the States. She was happy to accept for the same fundamental reason that she had chosen Oberlin in the first place: its strength in contemporary American art and the fact that the United States was the place to be at that time for someone who knew she was an artist (she already had the M.A. in sculpture from the Academy of Fine Arts in Athens), but meanwhile wanted to learn as much as possible about the new art. She was also glad to come because she liked the place and the friends she had made here, particularly Chloe Hamilton, curator, and myself. The job was to begin in the fall of 1963.

I had already seen a good deal of Athena in the summers of 1962 and 1963. Together with Maria Petychaki, a Greek friend of hers living in Paris, I attended Athena's public defense of her thesis at the Sorbonne. On a highly raised platform a row of professors from various disciplines sat like a tribunal and fired questions, which the little Mlle. Tacha, standing far below, alone in a huge space, answered with vigorous assurance. Maria and I were very amused as well as proud of how characteristically she had handled with seeming aplomb what was surely an intimidating experience for her.

In the summer of 1962, having intended to do some extended art travel after brief research in Paris, I decided to join up with Athena. We got a little old but undaunted Deux Chevaux Citroën which, by exhausting every ounce of its two-horses' strength, finally managed to cross the Alps while motorcycles and mopeds went flying past. There were plenty of opportunities for the little "Filly" to rest as we stopped over in the major museum cities, studying collections, taking slides and talking with colleagues.

This is when in Lucerne I went to see Jim Fitzsimmons to ask if he'd be interested in that article on Claes Oldenburg for *Art International*. (At the time it was a top magazine; it's very interesting how the contemporary art journals come and go in significance. In my view, *Artforum* has been sinking deeper in the doldrums for some time now; *Art News* has been coming back; *Art in America* and *Arts*, which

has been more volatile in its history, are holding a steady upbeat course. The *Journal of Art,* whose sudden demise is most regrettable, under Barbara Rose's editorship was a very useful source of current news in all fields of art, presented in a gratifyingly clear, straightforward, easy-to-find fashion, along with occasional articles that merited giving the publication shelf space rather than assigning it to the newspaper pickup.) After talking with Fitzsimmons about the piece I was planning on Oldenburg, he said he'd be glad to see it, so I resolved to write it that summer. But first there was the Venice Biennale and a trip to Greece.

Not having skipped a Biennale since soon after the Second World War, I felt I was becoming fairly familiar with Venice, but never enough not to be stirred, almost shocked, by its glorious movement of light and color. For several years I had stayed at a marvelous hotel, the Metropole not far from San Marco, whose enormous, airy rooms opened on the Grand Canal. However, like my favorite hotel in Paris, the lovely old Hôtel de France et Choiseul on the rue St. Honoré, it got upgraded from B class to luxury, leaving me far behind.

The Metropole being out now, I had reserved accommodations at the Pensione Seguso near the Accademia. This quiet little hotel where, according to a plaque, Ruskin had written *The Stones of Venice,* is ideally located for people who want to avoid the hurly-burly, Coney Island aspect of the area around San Marco, the esplanade and little alleys jammed with street vendors' tired displays of scarves, ties, beads and glass bits. One can sail right past all that on the way out to the Giardino where it is a never-failing delight to saunter down the cool green paths, going in and out of all the national pavilions, lingering in some and returning other days to examine further and take more slides of work that seems especially memorable, but hurrying through certain other exhibitions with just a nod—for example, the familiar social realist painting of lads and lassies glowing with health and happiness, at work in the fields and factories of the USSR. There were always some surprises, eye-catching or amusing, like a whole exhibition of live sheep (could it have been from Israel?).

In the 1960's the Venice Biennale was still a rich and lively assembling of work from a large part of the world; no one seriously interested in contemporary art could afford to miss it. Not to mention the important subsidiary exhibitions, extensions or offsprings of the Biennale at two or three other locations in the city (and at the Palazzo

Grassi always a major show of earlier art). Even now, in spite of Documenta and all the other huge international exhibitions of contemporary art, the Venice Biennale has something unique to offer, including a slow contemplative pace poles apart from the "Let's keep moving" impulse engendered by the newer big shows. I hope it has a long life ahead.

Most often I preferred to go alone to the Biennale, as on all my other art study-trips. (Going with someone was not so bad as what a student of mine overheard a man at the Detroit Institute of Art complain to his wife, "If you're going to stop and *look* at everything, we'll never get out of here," but bad enough.) However, going with Athena was, and remains, a delight. Her perceptive eye and wide-ranging mind doubled our pleasure, understanding and assessment of the work on view. I love to look at and talk about art (and nature and just about everything else) with Athena. It isn't just that we almost invariably agree in what we like and dislike, but we always understand what the other person is saying, and how rarely that happens even among the best of friends. Agreement makes for no less invigorating discussion than disagreement, but whatever the topic I am usually the one who profits most, as Athena has a far sharper and stronger mind with a more speculative bent, whereas I am pretty earth-bound and empirical.

Leaving Venice, Athena and I picked up the Deux Chevaux and headed for Greece via Yugoslavia. We drove right down the middle of the country; there was a highway in early summer of 1962, but no facilities along it. The first night we stayed at a hotel in a village and I got *turista* (and never got over it till we were out of the country). Except for a general over-all feeling of dust and dirt, I remember only three things about the whole trip. I heard a nightingale sing! Secondly, one evening while driving down the endless empty road, we saw something that seemed to be a mirage—a fine big brand new motel. We stopped, but there was no one there at all. We went across the road to an old house, where we registered and got the key to one of the units. It was clean and fresh, with good beds and a bathroom completely equipped with everything, except water. Not a drop in any of the bright new fixtures. It was maddening, but even more funny, and pathetic. My final memory of Yugoslavia was Skopje from a hotel room, a good big one with a bath where everything worked. Thirty years later I can still hear the strange sound that came through the

open window: a slow, steady, soft roar, or more like the heavy breathing of a great sleeping animal. I went to the window and looked down on the street, and there were hundreds and hundreds of people, walking, walking, walking. Apparently that was the local diversion for a pleasant summer evening.

That recollection reminds me of a somewhat similar occurrence in 1986 in a little seaport town of Northern Ireland, where Athena and I had gone to see the Giants' Causeway, that magic natural site. On Saturday night the main street, about seven or eight blocks long, was filled with cars slowly moving up one side and down the other, over and over again. I asked at the hotel what was going on. "Oh, on Saturdays people who own cars in the area 'round come into town and drive back and forth for the evening." A car "paseo"!

We left Skopje miraculously just ahead of a disastrous earthquake, and arrived late at night in Saloniki where we found a nice looking old hotel on the port. Well, waking next morning in a beautifully clean, cool, marble-floored room, I stepped out onto the balcony and fell forever in love. Sitting at breakfast, overlooking the blue Aegean (I've never been able to identify its specific color; it's simply Aegean blue), enveloped in the clear fresh air, the bright but gentle light, I had a strange sensation of having come back, as though Greece had always been there waiting for me to return, and I knew I would never be entirely happy away from there for too long a time. Indeed, in the thirty years since then there have been only two summers when I could not return even for a couple of weeks (and for the last two summers I have been home-bound for health reasons).

We drove down through the Vale of Tempe, a pass no more than a gash in the solid rock, passing Mt. Olympos at the best possible time of day, its peak soaring above the golden clouds at sunset, and on to Athena's home in Larissa. There we sat in their small but luxurious garden, fragrant of roses and jasmine in the sweet evening air, eating ripe olives and feta while sipping an ouzo (my first!). Curious how I never want ouzo outside of Greece; I've often brought a bottle home, where it sits in the cupboard for months or years until one of those rare occasions when Richard and Athena celebrate Greek Easter with a whole little lamb, which has been turned slowly on the outdoor spit for hours. Then the whole party thinks it's delicious to begin the feast with ouzo.

I was quite taken by Athena's father, Dr. Constantine Tachas, a

very handsome, elegant and deeply civilized person. There was an indefinable air of Paris about him, perhaps lingering from his years there as a medical student, but it was not at all conscious, simply a quality in harmony with his own being. Remarkable that he could have retained that gentleness and even sparkle through all his sufferings. After having fought in World War II he returned to a home and clinic destroyed by Nazi bombing. Then, being imprisoned for five years by the Communists and finally weakened in health and spirit, he came back to find his wife a virtual invalid with severe asthma and Parkinson's disease.

He and I enjoyed each other's company from the start. At first Athena's mother was a little wary of me since she could not communicate with me in English, and inevitably a bit jealous, partly because of Dr. Constantine, but mostly I think because she feared that I, of her own age, who could have had a child when she had Athena, might usurp some of her place. She needn't have feared; never was a child more faithful and loving than Athena, who wrote to her parents twice a week all the many years she lived away from Greece, and later, when she could afford to, also telephoning frequently. Although Nitsa spoke only a few words of English and very little French, it wasn't long before we had no need for words to communicate with each other, and soon she asked me to be Athena's "American mother" and take care of her (although, as it turned out, Athena takes more care of me).

Shopping in Larissa thirty years ago was fascinating; it was still thoroughly and conveniently compartmentalized according to artisans and other product suppliers (any connection with medieval guilds?): cobblers, jewelers, butchers, bakers, rug-makers, and *confiseurs*. Of course, all cities have scattered pockets of concentration. I know a section of several blocks of electrical supply stores in Athens—and naturally its touristically-motivated areas filled with leather straps, belts and purses, shish-kebob skewers, little brass pots for making Greek coffee, blouses and loose pleated cotton dresses (that you never see Greeks wearing, but which are extremely comfortable in the hot weather). New York has its garment district, its cluster of diamond merchants on West Forty-seventh Street (like many other such sections, it is partly ethnic, with many handsome Hasidic Jews that one rarely, if ever, encounters elsewhere in Manhattan), and Canal Street where you can find just about anything you want in plastics. But Larissa was different: *all* the shopping in the place seemed to be

compartmentalized in that way, like an Indian town, with its brasses here and its textiles there.

After a few days of shopping and visiting, all of us squeezed into the little Filly and drove south through the plain of Thessaly, past Mount Parnassus, and then on over to Delphi. In spite of the hordes of tourists, whose buses remained in the town, along with several of their passengers who preferred to enjoy the tempting shops rather than to trudge over through the actual site, Delphi still seems remote in time and place. Even now traffic cannot have silenced the oracle forever. Standing in the sacred Temple of Apollo and walking all through the Theater and up and down its steps, or following the path of the Treasuries and climbing up to the Stadium and on to the lower reaches of the awesome rock mountain with eagles soaring over-head, one comes to accept, all but *believe* in, the ancient myths and mysteries, and also to recognize or acknowledge the strain of barbarism at the core of the political, intellectual and aesthetic supremacy of classical Greece.

For a person like myself—just normally educated—it is in the great tragedies that this strain of barbarism is most apparent. Aside from how spell-binding it is to sit in the ancient theater at Epidaurus, or on the shank of the Akropolis, under the night-blue sky of Greece, not knowing the language at all is strangely enhancing. Being familiar enough with the play to know what's going on generally, without having to concentrate on hearing and understanding the dialogue, one can give oneself entirely to the pure sounds and expressiveness of the language, as well as its rhythms—its total poetry. Moreover one can pay closer attention, and so experience more fully the acting—the subtlety and force of facial and bodily expression in conveying meaning. To me it seems thus, without words, that the passion and violence are most inescapable.

But back in Delphi there is one of the two noblest bronze sculptures of the male figure in Western art. The *Charioteer of Delphi* is perfection in its totality and in every detail from the strong elegant toes to the tip of its sweetly curling hair. The other is the magnificent *Poseidon from Artemesion* in the Archaeological Museum in Athens.

We continued on from Delphi down to Athens, where I was amazed by the clarity and cleanliness of the air for such a large city. In 1962 even Piraeus smelled sweet and it was a delight to dine in the excellent restaurants at the water's edge. I remember Dr. Tachas (who

had long since become "Kostas") bought me a gardenia, from a flower vendor passing among the tables, which I didn't really need, the air itself was so fragrant. Now I avoid Athens as much as possible, going into the city only once or at most twice in the summer for banking and such, but principally to visit one or another of the museums, and perhaps a wine shop. What has happened to Athens and so much of Greece from pollution (motor vehicles, factories, and indestructible plastic) is tragic—as it is all over the planet, wherever our technological progress has penetrated. And in 1991, where hasn't it?

That first time in Greece I didn't get to stay on any of the islands, but we did make some day excursions to nearby places from Athens, for swims at such then still pleasant coastal beaches as Vouliagmeni and Kavouri, and we took a boat trip where we passed Poros, my first glimpse of an Aegean island with all its buildings a dazzling white against the bright blue sky and water. But it is not till one goes to such islands as Ios, Santorini, Paros, Mykonos (where everything, even the street pavements, are whitewashed) that one sees Cycladic architecture, with its softly rounded corners. In the old section of some island towns such as Syros, parts of houses are colored blue, green, rose—enchanting surprises in the brilliant white.

The boat ride and arriving at Hydra, rising up from the sea, was thrilling enough for that first year. We spent a few hours there; of course I had to ride a donkey, and we walked along the side of the hill away from the town to a little cafe where Nitsa and Kostas sat in the refreshing garden under the trees (the shade in Mediterranean lands is so astonishingly cool), while Athena and I climbed over the rocks and dangled our feet in the deep water, so clear that we could see the sun sparkling on the sand and pebbles at the bottom—my fist glimpse into and touch of that sea which has somehow become so essential to my inner and outer being.

Leaving the parents in Athens, Athena and I set out for Italy; driving along the north Peloponnese, we stopped for a brief swim off a beach of large, flat, sea-washed pebbles, the cleanest I had ever seen. After ferrying across the Adriatic to Brindisi, we drove around a bit. Near Ostuni were some of the most magnificent old olive trees I'd ever seen, although I've seen many grand ones since. I love those noble, gnarled old trunks and branches, and I wanted to incorporate a couple of photographs of them in the only book I thought of doing after my Guggenheim year investigating old age and creativity.

I had soon realized that the topic was far too complex to get more than a whiff of what would be needed in social studies, psychology, biology, medicine, philosophy of aesthetics, etc. to make the slightest contribution. After a year's study, observation and interviews, I arrived at two very general conclusions: one, I noticed that old people often become simply what they were before, but more so; and two, contrary to a commonly held notion that old folks get hide-bound and conservative, I more often encountered a released, more daring attitude: "Why not? What do I have to lose?" So I abandoned any big plan, but I did come up with something I'd have liked to do, and I made a fairly substantial précis with several specific examples of works of art selected from a wide range of times and places and interlarded with a few non-art objects, all of which would illustrate the book's title, *The Beauty of Old Age*. Across from each image would be a short text explicating it. I sent the proposal to a publisher (I forget which one, but a good small house that had asked me at the time if I had anything to offer). They regretted not finding it appropriate for them, so I put it aside and turned full attention to more pressing projects in contemporary art.

To return to Italy in 1962: driving north from Brindisi, we suddenly came upon an amazing structure, the like of which neither Athena nor I had ever seen outside of the beehive tombs of Mycenae, which its form most closely resembled. We learned that it was called a *trullo*, obviously no novelty to people who have spent time in that area of Italy, but we were enchanted and set our course deep into *trulli* land, where we came to a whole town of such buildings, Alberobello, I think it was. Such a strange anachronism to see an occasional television aerial protruding from the high totally domed structure. As we walked through the village, peering around, one nice lady invited us inside; it was a very pleasant little house, neatly divided into three separate living spaces, and heavenly cool.

Heading again northward we looked for a good place to stop for a couple of weeks, as I wanted some settled time to write up that first article on Oldenburg that I had been thinking about for several months, and Athena wanted to write her first Brancusi article. We located a perfect place, the hill town of Loreto, a quiet retreat, where we found a good, simple hotel with excellent, friendly service, the kind of food we both liked (we often saw the chicken being beheaded for our evening meal), and so quiet at night that the only sound outdoors

Old olive tree on Corfu, Greece; photo: Ellen Johnson, 1962

was the whirring of the myriad swallows or bats who lived in the rock cliff back of the hotel. Loreto is of course a pretty town, where thousands of pilgrims come to visit the Casa Santa of the Virgin. For a break in the heat of the day we would drive down and along the coast to the beach at Numana, for a swim and a little, but not too much sun.

It was marvelous to have Athena to talk with about Oldenburg; she was almost as excited as I about his work and gave me some excellent ideas. Ever since then we have talked with each other about our work. The quickness of her mind and the originality and depth of her thinking have been of inestimable value to me. I think I have helped her too, first in her writing and then in her sculpture, which I always enjoy seeing in progress and discussing with her.

Speaking of scholarly helpers, I must also mention another Oberlin colleague, Richard Spear. Richard is a splendid critic, putting his finger immediately on any weakness in the writings I've asked him to read. From time to time I have read articles and books of his too, not because I know much of anything about Baroque art, but because I do have some editorial talents. He came here in 1964 straight from Princeton, where he got the Ph.D. at the age of twenty-four, matching Athena's from the Sorbonne in two years. She had started working at the museum the year before as assistant curator, but was soon promoted to Curator of Modern Art, having begun to earn a distinguished reputation as such for her noteworthy exhibitions and publications, before the position even existed at Oberlin.

These two "whiz kids" were married in 1965 at my house in a delightfully unique ceremony conducted by Clarence Ward, Oberlin Museum's founder, with sections from the Jewish, Greek Orthodox, and Swedish Lutheran orders of service. What a boon it has been for Oberlin College to have managed to keep Richard and Athena here all these years, and for me such an incalculable blessing.

For just one example of their help, I don't see how I could possibly have restored the Frank Lloyd Wright house without them. Richard did a great deal of advising in spite of his heavy load as professor of art history, acclaimed publishing scholar, and Director of the Art Museum, a position in which he served brilliantly from 1972 to 1983 (among his many accomplishments: securing funds for an addition to the museum and art department building, and the services of Robert Venturi for its architect). Athena knows every inch of the house as well as I do, having helped me with decisions and carpentry throughout the

restoration and ever since.

When I bought the Frank Lloyd Wright house in 1968, it had been for two years in the hands of a local contractor-developer who altered it barbarously, thinking he was making it more attractive to potential buyers. In fact, he told me that if Wright could have seen the house after he finished remodelling it, he'd have liked it better than when he built it! I had understood that the house was seriously in need of several physical repairs, due to the original owner Mrs. Weltzheimer's increasing ill health, although, having been divorced and left alone, she managed to bring up and put through college her four children (the last was born while the house was abuilding, thus turning the master's work room into a fourth bedroom). Constructed from 1948 to 1950, the house is sited far back on a long relatively narrow lot; it had been longer, but the developer sold off three lots in the back. As called for in the design, there is a row of trees (evergreen) on each side and at the front on Morgan Street, the address given in much of the literature. But Mr. G., in order to provide another saleable lot, removed the long approach driveway and replaced it with a short drive behind the house, making the official address 127 Woodhaven Drive.

One of the first things I did was restore the original driveway, in keeping with Wright's design. With all the large windows on that approach, the house opens itself to the arriving guests, whereas the back is more private and closed, a long stretch of continuous redwood boards, with narrow, decoratively cut clerestory windows. The height of that extensive wall is about six-and-a-half feet; from it rises a stepped-back second level with plain clerestory windows. Of course I bought the lot at the front of the property, as it would have been unthinkable to have a house sitting at the climax of that marvelous unbroken space opening out from all the walls of windows. Moreover, if the developer had sold the Morgan Street frontage, it would have destroyed the orchard, which is a basic part of Mr. Wright's design from his first (1947) plot plan that he sent to Mrs. Weltzheimer soon after he agreed to build "a redwood and brick house for fifteen thousand dollars" (the actual cost, because of non-standard materials and systems throughout the house, was inevitably three to four times that figure). The orchard is on the same angle as the house, that is, slightly oblique to the rectangular lot, adding a touch of drama to the views of unobstructed grass framed by trees, different from each of the rooms.

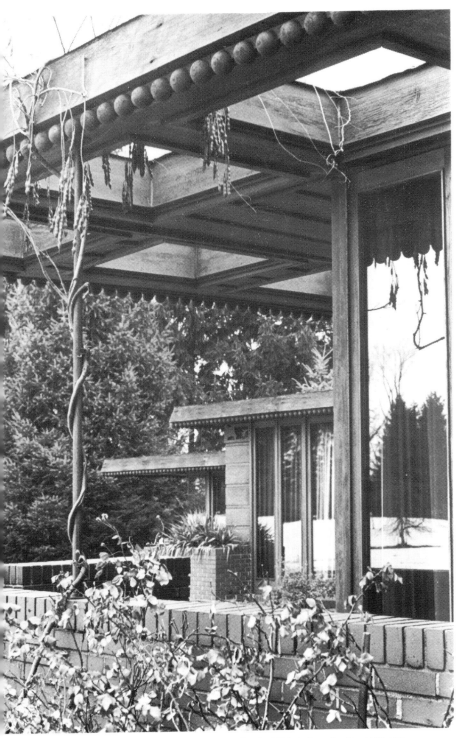

Ellen Johnson's Frank Lloyd Wright house (built for the Weltzheimer family, 1948-50),
Oberlin, Ohio, partial view of south facade; photo: Leslie Farquhar

The house is among those Wright called "Usonian" (a kind of USA Everyman house), L shape in its plan, the large living and dining area, the "work space" (kitchen), and the entrance occupying the base of the L, while the longer section holds the gallery, off which open the four bedrooms (one large and three smaller), and the second bath. On the side facing the expanse of lawn, all the rooms (except baths) have one or more sets of floor to ceiling (one hundred and eight inches) double French doors. (I never know whether to call them "doors" or "windows"; all or any old door can open out to the terrace or grounds, but very few windows are doors). The living room has four sets of them, alternating with plain windows of the same size; they completely fill the long wall and wrap around the corner. A majestic fireplace of brick occupies most of the north wall, which takes two steps back to a wide opening into the entrance hall.

Entering the house one is inevitably drawn into the light-filled living room, looking out onto grass (or snow) and trees and sky. One hardly even notices the window frames, only the great expanse of green or white space. (It is like a Brancusi or Arp sculpture in the winter, with the subtle wind-modelling of the untouched snow.) In all the rooms the outer walls that do not have French doors have narrow clerestory windows, most of whose panels are cut in a decorative pattern which, exceptionally in this house, are curvilinear rather than angular in design.

Sitting on the long built-in couch at the end of the living room opposite the fireplace wall, Ada Louise Huxtable, who was in Oberlin in 1972 to receive an Honorary Doctor's Degree for her architectural criticism, remarked, quietly as though thinking aloud, "It is one of the most beautiful spaces I have ever seen. The whole house is beautiful and everything in it is so good." I was of course thrilled by her comment and her immediate understanding of the house and of how hard one would try not to put anything unworthy in it and still have it be a thoroughly lived-in place.

Claes Oldenburg was awarded the degree the same year, one of the first in which students decided to revolt against the traditional academic hat and gown, appearing in a bizarre combination of styles in giddy colors and fabrics, if not dirty old jeans. I can still see Douglas Baxter (now director of New York's Pace Gallery) in the most bewitching wide-brimmed lady's hat. Claes and Ms. Huxtable endured the tedious hours on the platform, while each student marched across

it to receive the diploma, by trying to decide which of them was the best dressed. They finally settled on a girl who was wearing shoes and stockings.

In May 1968 I took possession of the house, but not without long deliberation and worrisome misgivings. First off, it had to be saved and restored to itself. I had hoped one of my colleagues would buy it, but none was willing or able to take it on. The physical problems alone were daunting; I had an excellent contractor and engineer go over the building carefully for me so I knew all about the badly leaking roof and the rotten wood and carpenter ants in the overhang off the little end room.

When my contractor, Glenn Hobbs, pulled off the redwood boards in that cantilevered trellis, a loathsome mess of sawdust and big black carpenter ants poured out onto the ground. But I was astonished to discover that it was only the fillwood that had rotted and been attacked by the ants. The redwood remained as proud and firm as the day it had been put up, proving what I had heard, but suspected was exaggeration: that redwood is impermeable to moisture and insects and all such instruments of destruction. There were a few other smaller necessary repairs, but the biggest challenge of course was the restoration.

However, that, along with all the other physical problems *could* be solved. I had other concerns and reservations of a different nature. What to do about the art works I owned and wanted to enjoy, not like a Chinese mandarin pulling a scroll out from time to time to contemplate it (that's nice too)? But I wanted to have them all around, to look at while sitting or moving through the house. I worried about the legend that Frank Lloyd Wright strongly objected to clients installing two- or three-dimensional art works in his houses, except for an occasional Far Eastern sculpture or Japanese print (a subject on which he wrote a book). However, as it turned out, the long gallery (actually his word for that hall) is an ideal space for hanging the kind of little things that I have—prints and drawings and a few small paintings. And how beautiful they look on the warm velvety wood. Because of Wright's method of finishing, one can see right into the depth of the wood; it becomes almost atmospheric, a friendly, visually penetrable space behind the picture. One literally *sees* how wood is a living thing.

I am thoroughly familiar with Wright's technique because I had to refinish all the new interior woodwork, due to the developer's cruel

alterations in three rooms, the long gallery and many lesser parts here and there. Wright's instructions on the blueprints for all interior redwood finishing are very explicit: apply a coat of one-half colorless shellac mixed with one-half alcohol, then sand it down. Apply another coat, another sanding, and still another of each process. Then rub beeswax into the wood and polish it, and repeat that two or three times. A lengthy and laborious task, but I love finishing and refinishing wood, so I didn't mind that Glenn wouldn't do it, partly I suppose because he felt he couldn't waste time on such tinkering things, including removing all the white paint the "bad man" had covered the brick fireplace in the master bedroom with and brushed *into* (not just on) the surface of several ceilings and the entire little end room. The end room is such an enchanting place, with a glass corner and two sets of French doors, one looking way across the lawn and meadow to the orchard and the other opening out and into a grand old spruce tree whose branches swing over and down the cantilevered trellis openings.

Speaking of how explicit Wright's plans were, the many architects who have seen them here say that no one makes such utterly complete blueprints now. A case in point, on one sheet Wright stipulated that all the hardware must either be selected by him or sent to him for approval, listing specific items including door handles, screws and toilet paper holders.

By far the most difficult question for me before deciding whether to buy or not to buy was: Do I really want to live in a work of art? Won't that be too demanding? Every little thing in the building is so determined and so perfect, how can I be myself in it? How can I live my own life adding its normal traces to an absolutely complete and beautiful work of art? Well, soon after moving in I realized, what I've been thankful for all the years I've been so incredibly lucky as to be in it, that this is an easy and comfortable house to live in—even a consoling one. It is the most serene of any Wright house I've been in. One feels rested just being in it. It is an ideal house to get well in, to recover from an operation or illness, and a good house to die in surely, if one can be so favored.

Moreover, the house doesn't seem to mind at all the clutter of my daily life (papers, books, magazines, photographs and slides, etc.) nor even all my snorkeling trophies: several open shelves filled with shells and coral (never taken alive) from the Caribbean, Greece and the Great Barrier reef, and many other treasures including some special pebbles,

a corner of a small marble capital with the egg and dart and acanthus leafcarving still visible after centuries of rolling in the sea just off the shore of Samos, and a little Mycenean clay pot.

This little Mycenean pot is a story in itself. According to the distinguished classicist, Brunhilde Ridgeway, the pot was filled with oil, ignited, and thrown over the walls (a kind of ancient hand grenade). Quite probably it slipped from the fingers of a warrior during one of the many attacks on the water-surrounded castle of Methone, and lodged itself protectively between two large stones in water not more than about ten feet deep for over three thousand years. One day a strange new sea creature, with a long horn protruding up from its mouth, swooped down and gently wiggled it out, thinking first it was a toilet ball, but then a roughly made modern little pot. So Richard and I thought, but Athena immediately said Mycenean. Sure enough the next day in the museum at Pylos we saw many of those irregularly shaped little pots all labelled Mycenean.

There was something else on the bottom of the sea at Methone castle that I longed to have—one of the several huge, magnificent stone cannon or catapult balls. Richard soon convinced me they were so heavy we couldn't even budge them. However, we did get several iron cannon balls from the Navarino battle (that is, Richard got them—they were far too heavy for Athena or me to bring up). Alas, they began to disintegrate in the open air, and by the time I got one back to Oberlin it didn't take long for the changes in humidity to split it into several pieces, two or three of which are on my shelves most compatibly with some bits of black lava from the Mauna Loa volcano.

To return to the house: no matter how difficult and tiring it may be to work on, it is never a burden. David Saunders and I were talking about this recently when he was visiting here and making some of the ever-needed little repairs; the house seems to give something back for the care given to it. It's like plants and flowers and trees; everyone who loves them suspects, or more likely knows, they show their gratitude for watering, spraying, feeding, pruning, and, I'll admit, a word or two softly spoken. Whatever one does for the house, from polishing the brass fixtures on doors, closets and cupboards to scraping off years of accumulated dirt and stain from the red polished floors with a paring knife or one's fingernails, one receives more than one gives. Being so largely of wood, the house is especially alive; it is never still, it shifts about and makes noises—it gives voice. As John Cage put it in one of

you or Ere night
not time I mile
The estal
of the
pia No.
Noisy E
itsel f
is musical.
Sini of the
pi NO.

John Cage

above: Ellen Johnson
in her Frank Lloyd
Wright house, in
conversation with
her former student
Jay Gorney, 1975;
photo: Robert
Stillwell

left: a page from
Ellen Johnson's
guestbook, with
poem by John Cage,
1973; photo: John
Seyfried

his name acrostic poems:

<div align="center">

you wEre right

not to incLude

the detaiL

of thE

piaNo.

housE

itseLf

is musicaL.

sound of thE

wiNd.

</div>

Reading over the preceding pages about the house, I am dismayed that I could write so much and say nothing. Nothing at all about all the little subtleties that one keeps discovering (how the sun shining through one of the curvilinear cut-outs in the gallery windows throws its golden image onto the redwood wall of the guest room, or how, when something suddenly appears out of key and is recognized immediately as the hand of the interloper, it is eradicated). Nothing about the *reason* one encounters throughout the house. I realize that there is a basic two by four module, but comprehend nothing more than that regarding the mathematical subtleties of the design. Such is beyond my ken. But I do respond deeply to order and to the *mind*, which is everywhere in the beauty of the house. Nothing about the ceilings that are such a joy to look up at on waking: the boards and battens are of course unchanged in width throughout the building, but their length is varied so that there is a different ceiling design in each room.

Worst of all I haven't even mentioned the fundamental character of the house. Discarding the traditional raised foundation, it simply rises up from the flat land as though it grew right out of it and still clings to it. It is a horizontal house in every respect, which is still maintained in the asymmetrically beautiful variations in roof levels. The outer wall boards run horizontally, and are of the same width as the interior ones and also separated from each other by a similar wooden band of about two inches, whose bottom is flush with the wide board below it, but whose top is beneath the upper board. This device creates a shadow, thus reinforcing the basic horizontality. The exterior and interior brickwork follows the same design: the horizontal bands of masonry are recessed, while the vertical ones are flush with the bricks;

ergo, more horizontal shadows. (No wonder the first thing I did was remove the vertical television aerial).

While the effect of the repeated horizontals rising from and continuing the flatness of the land is very beautiful indeed, I must admit that it does cause some problems in the brickwork. Rain, ice and snow collect and rest in the recessed bands and gradually split some of the bricks and crack pieces off necessitating minor repairs each spring. That little sacrifice for aesthetic good I gladly go along with, but it's the kind of thing that gave Wright his highly undeserved reputation for impracticality. Yet, what could be more practical than the interior walls? If there's a leak somewhere all you have to do is remove a few screws from a couple of boards, pull them off and screw them back on when the leak is attended to. No plaster, no wall paper, no paint. No mess. Another nice little practicality is the neat way the screens operate on the perforated panel windows in the gallery and on the upper level clerestory windows. Just raise the screen, push the window out with your hand and release the screen. What could be simpler? And they work perfectly.

Moreover, when Wright designed the Weltzheimer house, he had been experimenting with solar heat. Thus he sited the building at an oblique angle to the lot to take advantage of the sun's position in the varying seasons. In the living room with its great expanse of windows facing south-west, at the height of the summer the sun comes only about two feet or so into the room, whereas in the deepest winter the sun goes all the way across the room and on out into the kitchen through the "colonnade" of brick piers between the two rooms.

Wright also called for broken limestone on which to "float" the building and installed radiant heat (hot water pipes in the concrete floors). Further, the dark red color of the floors enhances the solar heating system of his design, since dark colors absorb sunlight. Clearly the basic principles of solar heating are definitely at work here. Even with only single-pane plate glass, this building is not, as I feared it would be, at all expensive to heat. On the contrary, I have sat in the living room in zero weather, when the automatic furnace has gone off and the room is at eighty degrees. In any case I've never been bothered by the heat or cold and have always been wonderfully comfortable in the house.

FRAGMENTS

VII

How lucky I've been not only to live in a beautiful Frank Lloyd Wright house, but to do so in Oberlin. I've never for a moment considered leaving since I first started working here in 1939, except for a few forays into other academic territories for a semester. I taught at the University of Wisconsin, Madison, in 1950-51, Uppsala University, Sweden, in 1960, University of Sydney, Australia, in 1977, University of California at Santa Barbara, in 1979. I have also held a special chair for one- or two-week lecture series at various places including the University of Michigan, Ann Arbor, Texas Christian University, Fort Worth, University of Texas at Austin, the Power Lecture in Contemporary Art throughout Australia. And of course I've given hundreds of individual lectures all around this country and some abroad.

Summers were spent in Europe studying and taking slides at special exhibitions as well as following the regular routine of museums, galleries and studios. After that first trip to Greece in 1962 I managed to conclude the summers there where I could get away from modern art and just swim, read, think and write. Shorter holidays and weekends were for art trips in this country.

It was all a lot of work, lugging camera equipment, books, photographs, catalogues, trudging from gallery to gallery up and down stairs (in the old days several galleries were second and third floor walk-ups), setting up equipment for slides, writing down the information for them, all day long on foot, or on buses and subways, till gallery closing time. Then I would grab a hamburger or other bite on the way to some artist's studio, invariably up more flights of stairs. Finally late at night I'd go back to the hotel, shower, make notes, get in bed and eat a pint (if happily no smaller size available) of chocolate ice cream while reading a chapter or so of a detective novel to pull the curtain on the day's work. Then up the next morning and begin all over again.

One time when I was leaving the building Claes Oldenburg had just bought and was moving into, I asked him where the nearest subway stop was. Startled, he declared, "But you can't ride in the subway at night!"

"Of course I can. I always have."

"No, I'll come down with you and find a cab."

"Claes, I can't afford to take a taxi."

"Well then, I'll pay the cab fare."

So I said, "Okay, if it will make you feel better." By that time he had long since graduated from watching his pennies as he had had to do when we first knew each other.

Aside from the matter of cost, which for many years really did make a difference for me, and aside from having been brought up to save on little things so as to have money for the larger ones (including all the study trips and a few little art works), aside from having lived through the Great Depression that left me and many of my contemporaries unable to spend money unnecessarily on ourselves, aside from all that, I've always preferred subways and buses because of all the different kinds of *people* on them, each one so absorbing to look at and watch. Riding on buses and subways seems so much more human to me than being isolated in a taxi, shut up in a little private glass and metal moving world. However, now I *have* to take taxis (unless there happens to be a bus right at my door), but they are a torment to my banged up old body. The springs in the back seat are usually so shot that I have to hold myself up with my hands, which gives me a good reason for sitting up front with the driver.

So it was, wherever I went, strenuous work gathering art material —except in Greece, and later also the Caribbean; they were both restful and productive. There being little modern or contemporary art compelling me to rush around to see and document, I was free to think, without distraction, about the art I had seen elsewhere, study it from slides and memory, sort it out, let it grow in my mind, evaluate it, and eventually start to write about it. Thus, paradoxically, being away from art brought it closer to me. That is also one of the reasons why for me it has been so valuable to live in Oberlin, one hour and fifteen minutes by plane from New York (and an equal amount of time at least getting to and from the airports at each end), where I have never been able to get over the pressure of just one more, and then another and another unending number of exhibitions demanding to be seen. Back in Oberlin the assimilating and assessing occur right along with a full load of teaching (they feed each other). Besides, as I've said so many times, I can't think without being able to see trees and sky.

Unquestionably art travel is exhausting, but it's so totally absorbing and fascinating that one doesn't notice the aches and pains. I am grateful for every trip I have been able to make. Besides the art

Ellen Johnson, with Robert Venturi and Oberlin College President Emil Dannenberg, breaking ground for the Allen Art Building's new wing by Venturi & Rauch, inaugurated in January 1977; photo: Robert Stillwell

Slate roofs in Makrynitsa, Mount Pelion, Greece; photo: Ellen Johnson, 1970

Ellen Johnson's Frank Lloyd Wright house, interior, living room;
photo: Leslie Farquhar

itself, there are all the artists I've talked with and gotten to know, several of whom have become friends. Moreover, it's all part of teaching. How can one possibly teach the history and criticism of art without seeing it, the real living thing, not just slides and photographs of it?

Obviously one of the greatest pleasures of living in a small college community (with the intellectual and cultural advantages of Oberlin) is being in the midst of young students, who wave from their bicycles, or smile and speak when meeting on the street. They are so friendly, and even when retired, one somehow manages to get to know some of them. Moreover, I'm so extraordinarily lucky that the young faculty in the art department seem to like to come to see me, largely of course because of the house, at least in the beginning, but more often than not they become friends. Exchanging ideas, or just enjoying each other's company is another of the blessings the house, and Oberlin, have brought.

It's hard to imagine a more rewarding job than teaching, and the rewards are on-going. Those fresh-eyed students, whose stimulating, independent papers and discussions open one's own eyes to things unnoticed before and one's mind to new ideas, don't stop with a "thank-you" letter upon leaving Oberlin, but continue to keep in touch over the years, writing, calling, visiting, sending copies of their books and articles. A special kind of gratification comes from receiving post cards ("When I saw this Cézanne *Bathers* at the Tate, I just had to send it to you and to tell you that on all my business trips all these years, I've never missed going to museums or galleries."), letters, and other mailings from students who were anything but art majors and had taken the big (several hundred enrollment) modern art course, ten, twenty, thirty or forty years ago. Some of them went on to take the next level course, in contemporary art, or a course in some other period altogether; but far and away for most of them that was their only art course.

One day in the early 1970's there arrived from Vietnam an exquisitely lacquered jewelry box with a lovely note from Laura Palmer, a government major who had taken Modern Art and a couple of other courses in a different art period. Two months after she graduated she was in Vietnam, where she remained as a reporter for two years. She transferred and went to Paris, but returned to Saigon "when Vietnam began to become unravelled, once and for all." She

was there for the U.S. evacuation of Saigon and left on a chopper just the day before the government of South Vietnam surrendered.

Laura has kept in touch, writing occasionally, and visiting me when she returned to Oberlin for a Vietnam Memorial weekend and again for an "Alumni Collects" exhibition at the museum, to which she loaned a piece. Then suddenly came a copy of her very moving book of selections from all the letters, poems and other messages from the living to the dead left on the Vietnam Memorial (*Shrapnel in the Heart*, New York: Random House, 1987). She managed to locate a good many of the writers and travelled all around the country to talk with them and hear their stories, which, written by her, were still filled with their language and their pain.

And now in 1991 has come the book Laura co-authored with Elizabeth Glaser, who contracted AIDS from blood transfusion, transmitted to her new-born daughter through breast feeding and directly to her son who was also born before the girl Ariel's illness was finally diagnosed as AIDS. Ms. Glaser tells of her grim and courageous struggle to try and save her daughter's life (and her own, of which she almost never speaks) and to preserve her son's. She describes her battle against ignorance, fear and apathy, and how *In the Absence of Angels* (New York: Putnam, 1991) she set out, with the help of a few loyal friends, to finally establish the Pediatric AIDS Foundation.

Laura Palmer has already begun another book, again drawn from her compassion and concern. A few days ago she called to tell me that she and another Oberlin alumnus would so like to get me to New York to go through the Annenberg collection with them. That being out of the question just now, she sent me a copy of the handsome catalogue and said she and Christopher would come out to see me soon. And once more she declares she's ready to go snorkeling with me in the Caribbean whenever I say the word. It's a good thing to think about even though at this point it doesn't seem very feasible. But Athena is still hoping that together we can manage it (she knows so well how to help me); her saying it's not impossible keeps my hope up. It would be so lovely to swim once more in the clear warm sea with all that marvelous underwater life.

A short time ago someone brought to my attention a long interview (in *Topics*, Oberlin, Spring, 1991) with an alumni couple who have been very generous to the College. They were asked how it happened that they supported Oberlin rather than their graduate

schools. He answered: "Law school didn't prepare me for what I do now. In the most fundamental sense Oberlin [did]."

She added, "Professional schools give you the tools to work with, but the essential skills are things I learned at Oberlin."

In concluding the interview he said, "And there's a benefit to a liberal arts education that goes way beyond the workplace. Just one example: both Judy and I took Ellen Johnson's 'Modern Art,' and we are much richer for it." I don't happen to remember either them (I might if I see them), but in a dark room with anywhere from one hundred and fifty to four hundred and fifty students, it's more amazing when I *am* able to put a face and a name together. However I do remember many papers and a great many faces.

It's astonishing how when you're giving a lecture with slides, standing on a raised platform and looking down into a large black space, suddenly an individual face will emerge from the darkness and you are looking right into a pair of intelligent, understanding eyes— communicating directly. It happens often, sometimes with a follow-up: you recognize the face when you encounter it in the halls or on the street and exchange knowing greetings.

While one of the disadvantages of accepting unlimited enrollments is the difficulty of exchanging ideas directly with students, still it's remarkable how much exchange can take place between a student writing a paper and a teacher reading and noting comments on it. Moreover, in my case, the opportunity for personal contact was always provided with ample office hours and optional discussion periods, which, except just before an announced test, tended to draw more bright and stimulating students than those who needed help.

By no means was I centering my efforts and attentions on the art-minded students. On the contrary, I thought every one should have the chance to look at, and learn, and think about, and try to find something of the meaning in all those wonderful works of art. In one of the critiques that Oberlin students write at the end of each course, and that the teacher gets a chance to read only some time later, I received a compliment I've cherished above others on my teaching: "She made my life nicer."

That certainly does not mean that I'm not grateful and proud of all the students who have gone on in art—museum work, teaching, dealing, writing, painting and sculpting. Although I receive letters, and announcements of exhibitions, and read with joy their publications and

other professional distinctions, the ones I actually see most often are New York dealers, particularly Douglas Baxter who was for many years with one of my most favorite dealers, Paula Cooper, and is now Director at Pace Gallery, and Jay Gorney who has a gallery of his own. It is natural that I see the dealers more often than my former student colleagues in the teaching and museum fields who are all around the country and whom I see mostly only at the annual College Art Association meetings. I go to New York fairly frequently, and occasionally visit the West Coast and Chicago, to look at the new art, which means going from gallery to gallery.

While teaching was my number one profession, the things that happened and the people I got to know while out in the field in pursuit of living art and artists were equally engrossing and exciting in a very different way. Just now I'm remembering how I sprained my ankle sitting for Alice Neel. I don't know if that was before or after I started working on a piece I wanted to write about her. Of course I had seen her work before, and I remember spending quite a bit of time with her at her large retrospective at the Georgia Museum, University of Georgia, Athens, in the fall 1975. I don't recall how I happened to be there, perhaps to give a lecture. On the other hand I may already have been working enough on Neel to have made the trip just to see her show. It was probably then or soon after than she asked me to sit for a portrait. I did so during spring break of 1976, about nine or ten days including weekends.

Every day I left my little cheapo hotel (just a bit east or west of Fifth Avenue), and took a nice leisurely bus ride up to the corner of Broadway and One-hundred-and-seventh Street (#300) where Alice Neel lived in a wonderful big old rambling apartment. When I arrived, as expected, at 11:30 or so, she'd be sitting in the kitchen at a good solid bare wood table eating her standard breakfast of cheese, nothing else, just two or three excellent cheeses. We'd sit for an hour or two talking and munching.

Alice Neel *loved* to talk and happily let flow all sorts of things about her life and art, mostly life. Much of her "real life drama" was by then fairly well known, but it was fascinating to hear all the details direct from that brave exemplar of women's liberation thirty or forty years *avant la lettre*.

In 1925 she married a Cuban. She had her first child, Santillana, in Havana, then moved back to New York. A year later the child died.

Another daughter, Isabetta, was born the next year. Alice's husband kept drifting off to Europe or Havana taking Isabetta with him. Apparently from 1933 Neel didn't see him anymore. In the meantime Alice had tried to kill herself, and spent some time in a mental hospital. Next she took up with an opium-smoking sailor who, in 1933, destroyed over sixty paintings and three hundred drawings and watercolors in a mad rage. Her next man was a Puerto Rican singer and guitarist with whom she lived from 1935 to 1939, when her first son was born. Two years later, while she was living with a Russian photographer and filmmaker, her other son was born.

To have children and bring them up without marrying (or even having the father around) was far more courageous and difficult fifty years ago than it is now, when it seems to me that any young teenager can get pregnant, keep her baby and go on welfare. But Alice Neel was an independent, unselfconscious and stubborn woman—at least a determined one. I don't think Alice was *flaunting* her behavior as a deliberate defiance of convention; I think she was simply living her life in her way as honestly as she could and accepting what her acts and attitudes brought to her. The Swedes have an adage: *Om man tar fan i båten, så får man ro honom i land* (If you take the devil in your boat, you have to row him ashore).

Her husbands and the fathers of the boys were all handsome men, dark and impressive in bearing. Alice Neel was always very sweet and innocent looking. Despite the biting, even cruel comments she often made about her portraits, she always remained fundamentally innocent; it was one of the amazing things about her.

Alice Neel was a liberated woman not only in her personal life, but also in her socio-economic and political activism, taking part in rallies, demonstrations and strikes (and painting portraits of the major Labor organizers, including Pat Whalen and Bill McKee). She participated in the Hunger March in Detroit in 1932, and she helped with the endless bread-lines of starving, homeless, helpless victims of the Great Depression. There was one effect of that Depression that is rarely, if ever, noted. People who lost everything, meaning most everyone, surprisingly often shared what little they could dig up with the even more needy. I realize I may be sentimentalizing and looking back for compassion, but I did see many such examples in the desperately impoverished city of Toledo.

Neel's great big eight room apartment (I saw only the kitchen and

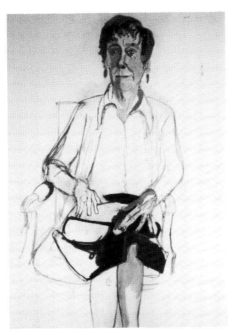

A stage in the development of Ellen Johnson's portrait by Alice
Neel; photo: Ellen Johnson, 1976

the sitting room) was, she said, overflowing with paintings, stacked all around and stuffed in the closets. Sometimes she brought in some paintings to show me (and of course I had seen lots on exhibition). There were some still lifes and a few landscapes, but primarily portraits. There they stayed, either because the sitters didn't like them (she was anything but a flatterer), or couldn't afford one, or never even thought of owning one, particularly the Puerto Ricans, whom she liked and painted so often, having lived in and around that part of Harlem since 1938.

On my first session, after she finished eating and talking, she became all business. She took me into the painting room and then began what I suspect was almost a standard plea: "Will you pose in the nude?"

"Not at my age, Alice, I did when I was a student to earn a few cents in the early 1930's." (It was very funny: we had to wear a one-piece bathing suit for life drawing.)

"Oh, come on, don't be so silly."

"No, I don't want to"

"Well, at least take your blouse off."

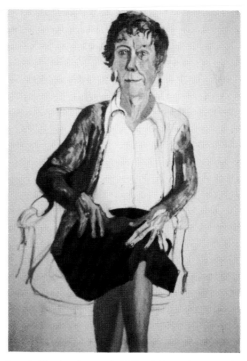

A stage in the development of Ellen Johnson's portrait by Alice Neel; photo: Ellen Johnson, 1976

"No, let's get to work. My blouse fits snugly enough so you can get plenty of body information for your portrait."

I realized that Neel liked to paint the nude figure and didn't want professional models for many reasons, not just economical even when she was very poor. One of the strongest reasons, I suspect, was that she wanted to paint the body, not the body *and* a portrait, but the body as an essential part of the portrait. Also the body of someone who is totally unused to being naked before a stranger would have a kind of awkward poignancy that no professional could assume. Moreover she delighted in being piquant if not downright risqué. Whatever the reason, she frequently began her sittings with that stripping request. If nothing else, it was a unique icebreaker—though Neel needed no ruse to break any ice.

During the long week or more that I spent sitting, at the end of the day on two occasions friends came to pick me up. After introductions she asked both couples "Will you pose in the nude for me?" Richard and Athena Tacha Spear would gladly have obliged if they could have found that much time. But the thought of the other couple (Andy and Marjorie, retired friends from Oberlin living in New

York) sitting for nude portraits was too funny.

I was reminded of a hilarious incident that occurred when we were spending a week or two together on Mykonos and one afternoon made a little excursion to the Island of Delos. As soon as we got off the boat Andy, seeing so many other people swimming *au naturel*, dropped his shorts and dove in. Marjorie was furious; snatching up his shorts, she swam out holding them in her teeth like a dog, and made him put them on immediately.

I said, "Why in the world did you do that?"

Her reply was unexpectedly provocative, "Oh, I didn't want you to see his ugly old body!"

Fortunately, Alice Neel did get to do some double nude portraits, including the well-known one of Cindy Nesmer and Chuck, for which Cindy wrote a witty account of the pre-painting process.

Forgetting her desire to have me sit in the nude, which was obviously something she just tried for on the off chance, Neel finally sat me down in the familiar arm chair saying, "Cross your legs, move your body around a bit, do something with your hands." I kept wiggling about until suddenly she commanded, "Hold it! That's it, don't move!"

After about ten or fifteen minutes I said, "Alice, I do have to move for a minute!"

"Nonsense! What are you, a baby?"

After several more minutes of rigid posing, I begged, "Please, Alice."

"For heavens sake, can't you sit still?!" (I kept hearing Cézanne, "Does an apple move?!!")

Finally, I said "I'm standing up," which I did, and toppled right over. My totally numb leg crumpled and my ankle turned under me. After that she gave me a little more time to move around and take a few slides of various stages of the process.

It was fascinating to watch her work, absolutely directly, no preliminary sketch. She simply loaded the brush with a thin solution of oil paint and turpentine and quickly drew the outline of the whole thing. Mostly, for the sketch she picked up blue paint, occasionally ochre. She then began building the work up more slowly, but still with positive strokes, no fumbling.

I think it is a good portrait, but not one of her great ones. I like the hands especially, but then her hands are always individual and deeply

expressive. In the article I wrote on Neel's portraits (*Studio International*, March 1977, 174-79), among the photographs I included several telling details of hands. It would be hard to find any Neel hands (and to a lesser degree, feet) that are not communicative.

As Alice Neel became more widely appreciated, she began to receive invitations in her late years to give slide talks, in universities and colleges especially, all across the country. When she showed slides of portraits, invariably she'd let fall little outrageous remarks, taking special delight in comparing people to animals: "She looks like a ferret, doesn't she?" Virgil Thompson suggested an elephant, someone else a carp, and she called Bob Smithson "the wolf boy." As most anyone else would, I wondered what animal I made her think of, but while I saw her from time to time I never thought of asking her.

One evening two or three years after she'd done my portrait, we were sitting together at some buffet supper party after an opening having a good time talking with each other when she suddenly said, "You know, I'd like to do your portrait again. You're beautiful, and I didn't see that when I painted you. I was just thinking 'Ellen Johnson, Art Historian.' " She certainly did herself an injustice in that remark. Neel never in her life painted a type, only unique human beings, with this or that characteristic exaggerated, but always that very particular individual. Moreover, while she was at work on my portrait, in one of her occasional little asides, she said, "You won't like this portrait because I'm making you look a little askew. But you *are* a little askew; you certainly aren't *square*."

Compared with the ordeal of sitting for Alice Neel, sitting for David Saunders was a pleasant little afternoon visit and conversation. He had previously taken a few quick photographs, painless—no rigid posing. So when I came for a sitting he had the lights carefully arranged, the easel all set up supporting a large canvas on which was already painted a sketch or first draft of the face. After seating me, he rearranged the lights a bit and looked a lot, then laid out the oil paints he expected to use and set to work carefully using the colors to establish and form the features.

After a couple of hours we broke off, left his basement studio on Lafayette Street and went to some galleries together, which we do from time to time although he complains I wear him out. Well, it is a complicated and concentrated business, but surely not as much so as painting a portrait (or making a large public sculpture, a field Saunders

pages from Ellen Johnson's guestbook, with dedicatory drawings and writings by Claes Oldenburg (1970), Joel Shapiro (1989) and Tim Rollins + K.O.S. [Kids of Survival] (1990); photos: John Seyfried

has also worked in, producing as yet relatively few but very fine pieces). Looking at art being such a demanding task, David likes to take occasional breaks, talking between times. Although Alice Neel's talk was fascinating, and informative about her personal history, she never talked about serious intellectual matters, whereas Saunders, who also talks a lot, never talks about anything else.

Unlike Neel, who required me to stay right there the whole time, Saunders did far and away most of the painting without me, only asking that the next time I came to New York I drop in for some checking and adjustments. His picture is in a unique and evocative technique of two canvases attached together, with cut-out areas on the lower or background section, thus achieving multiple layers and levels of meaning, as well as visual interest. (I have written at some length on this ingenious method in an article on Saunders in the *Allen Memorial Art Museum Bulletin*, XLIII, 2, 1988-89, 10-23). The meticulously painted, brightly lit face emerges from a more fully and openly brushed, many-colored—predominantly "Cézanne" blue—surround, in which are incised and cut-out images, directly and personally associated with the sitter.

When David was showing some work in Cleveland he came out to Oberlin to make drawings (what a draughtsman he is!) of several cherished objects in and around my house which he incorporated into the portrait. He drew coral, the Gucki for viewing slides, a star fish, the bird feeder, a wine glass and bottle (I've never collected art but I do collect wine, and I read about wines as avidly as some people read recipes, and revel in the monthly tastings a small group of us have), a deer (my favorite animal), the camera around my neck for taking slides and in my hands the paper and pencil for listing and identifying the works, a pottery pitcher from one of my favorite paintings in our museum, a Chardin still life. Altogether it is a very impressive portrait. Although perhaps a bit too Margaret Thatcher for me, it is a beautifully and caringly painted work.

Strikingly different in its informality is a smaller portrait that he brought me when he came to see me this summer. A total surprise—I didn't know he was doing it and had not seen the snapshot of myself that served as his model (probably taken the same time as those for the large portrait, or perhaps a year or two later). It is one of the pastels on a Boydell Shakespeare engraving, a series that he has returned to from time to time in such a rich variety of style and expression ever since I

above: Ellen Johnson with her portrait by David Saunders in his studio, New York, 1991; photo: Athena Tacha

right: Ellen Johnson at the opening of the exhibition of her art collection, "The Living Object," Allen Memorial Art Museum, March 7, 1992, two weeks before her death; photo: John Seyfried

first saw his work in 1981. Those paintings and drawings in pastel over prints I have always most especially admired. In the recent portrait of me the pastel is lightly and vividly (bursting with life) drawn over a scene from *A Mid-Summer Night's Dream* (this sheet by Fuseli). The lightness of touch of the pastel allows details of the figures to appear here and there, fragments peeping in and out from under: a good section of Bottom's head and his leg, a bit of Titania in the hair along with the faces, arms, legs of Pease Blossom, Cobweb, Moth, Mustard Seed and one or two other wildly and gracefully dancing figures, a dancer's hand on the sitter's brow, a couple more on the chin, a little face under the eye and another along the nose. Everything is marvelously interweaving like dreams, and like reality itself.

David Saunders, *Portrait of Ellen Johnson*, 1991, graphite, charcoal, watercolor and collage on an 18th century engraving of "Midsummer Night's Dream," 22" × 17½", Estate of Ellen H. Johnson; photo: John Seyfried

Athena Tacha, *Feather Armour for Ellen (Head and Torso)*, 1992, feathers on expanded aluminum and mixed media, 62" × 24" × 21½", collection of the artist; photo: Richard Spear

Forbidden Subjects: Self-Portraits by Lesbian Artists

Twenty-six lesbian artists look at identity, community, subjectivity, pain, anger, love and survival with exciting images and thoughtful, provocative writing.

#**C10** ISBN 1-895640-01-6, 100 pages, 4 in color, 5½" x 8½"........................$8.95

Give Back: First Nations Perspectives on Cultural Practice

Artists and writers discuss the process and potential of creative work, contrasting Native and European intellectual traditions. Jaune Quick-to-See Smith, Maria Campbell and four other artists argue for a radical revisioning of culture and the functional relationship between the artist and the community.

#**C11** ISBN 1-895640-02-4, 96 pages, 5½" x 8½"..$6.95

Art and Survival: Creative Solutions to Environmental Problems *by Patricia Johanson*. Johanson works with engineers, city planners, scientists and citizens' groups to create her art as functioning infrastructure for modern cities. Her graceful designs for sewers, parks, and other functional projects reclaim degraded ecologies, and create conditions that permit endangered species to thrive in the middle of urban centers.

#**C8** ISBN 0-963361-9-5, 36 pages, 4 in color, 5½" x 8½"................................$5.95

Art and Healing: An Artist's Journey Through Cancer *by Jan Crawford*. At the age of twenty-nine, Crawford learned she had cancer of the lymphatic system. This book is the record of her journey through the disease and the ravages of chemotherapy to her eventual recovery. *Art and Healing* is a story of hope and affirmation. The book explores the age-old healing tradition of art as therapy and a source of spiritual renewal.

#**C7** ISBN 0-9393361-8-7, 36 pages, 13 in color, 5½" x 8½"...........................$5.95

Come Spring: Journey of a Sansei *by Haruko Okano.* Okano fights racism and internalized racism to uncover her personal history and reclaim her Japanese-Canadian culture and heritage. *Come Spring* is the strong story of a child's survival through the most painful conditions human beings inflict on one another. It is the story of a

woman's incredible achievement.

#C9 ISBN 1-895640-00-8, 52 pages, 4 in color, 5½" x 8½"..............................$6.95

In My Country: An Anthology of Canadian Artists. Nine Canadian artists from diverse cultural backgrounds consider the best and the worst of their country. Where do we see the seeds of the world we want? Remarkable insights and fine new work promise hope for a unique country.

#C6 ISBN 0-9693361-7-9, 48 pages, 5½" x 8½"..$5.95

Meat: Animals and Industry by Sue and Mandy Coe. Sue Coe's shocking indictment of the Meat Industry. Mandy Coe, in a text written with her sister and exploring their shared ideas, discusses the power of cultural work in assisting resistance and change.

#C5 ISBN 0-9693361-6-0, 24 pages, 5½" x 8½"..$3.95

Wild Things: The Wisdom of Animals. Nine new and emerging artists celebrate the beauty of animals and explore their spiritual power.

#C4 ISBN 0-9693361-4-4, 24 pages, 5½" x 8½"..$3.95

Family: Growing Up in An Alcoholic Family by Tee Corinne. The well-known writer and artist heals her childhood experience.

#C2 No ISBN, 16 pages, 5½" x 8½"..$3.95

Quilts As Women's Art: A Quilt Poetics by Radka Donnell. In a writing informed by the practice of quiltmaking itself, Donnell pieces together philosophy, stories, poetry and illustrations in a celebration of quilts as women's art.

#D1 ISBN 0-9693361-2-8, 168 pages, 5½" x 8½"...$12.95

Creaturecards by contemporary women artists. A set of six full-colour folded notecards with envelopes, featuring art about animals.

#F1 5½" x 8½" folded to 5½" x 4¼"... $6.95

Add $3.00 shipping per order.

Make checks payable to **Gallerie Publications**, 2901 Panorama Drive, North Vancouver, BC, Canada V7G 2A4. Phone: (604)929-8706.

Gallerie Publications: publishers of contemporary women's art since 1988.